BASEBALL
IN
ATLANTA

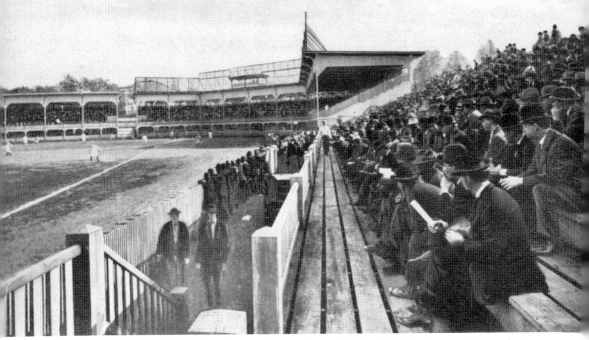

Ponce de Leon Base Ball Park, Atlanta, Ga.
"Watching the Game."

An Atlanta postcard from 1910 depicts a view from the left field bleachers at Ponce de Leon Park, the home of the Atlanta Crackers, a legendary minor-league team that operated from 1901 to 1965.

FRONT COVER: Hank Aaron drills another home run during the final stages of his historic chase of Babe Ruth.

COVER BACKGROUND: The 1957 Atlanta Crackers pose for a team portrait.

BACK COVER: This aerial view looking north over Atlanta–Fulton County Stadium toward downtown Atlanta was taken shortly after its construction in 1965. Atlanta–Fulton County Stadium was the home of the Atlanta Braves from 1966 to 1996. After the conclusion of the Centennial Olympic Games, Centennial Olympic Stadium was converted to a baseball stadium and renamed Turner Field. The stadium has hosted Atlanta Braves games since 1997.

BASEBALL
IN
ATLANTA

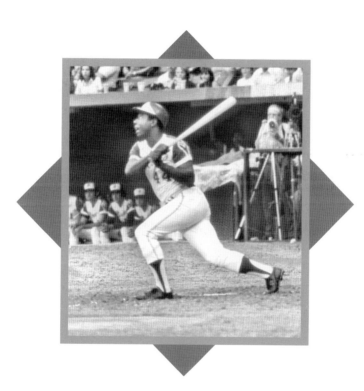

Paul Crater
Foreword by Pete VanWieren

ARCADIA
PUBLISHING

Published by Arcadia Publishing
Charleston SC, Chicago IL, Portsmouth NH, San Francisco CA

Printed in the United States of America

Library of Congress Catalog Card Number: 2006932782

For all general information contact Arcadia Publishing at:
Telephone 843-853-2070
Fax 843-853-0044
E-mail sales@arcadiapublishing.com
For customer service and orders:
Toll-Free 1-888-313-2665

Visit us on the Internet at www.arcadiapublishing.com

CONTENTS

FOREWORD

As a lifelong student of baseball history, I have always enjoyed reading about the game, poring over old box scores, and examining photographs that capture moments from the past.

As a longtime Braves broadcaster, I've had the good fortune to be a part of that history in Atlanta.

It is a history that dates back to the 19th century, and it closely mirrors the evolution of Atlanta as a city.

First, there is the post–Civil War Atlanta, rebuilding—and launching—its baseball life with a variety of amateur teams.

Next came the sleepy Southern town with its highly successful minor-league team.

By the 1960s, Atlanta emerged as the hub of the civil-rights movement, and in 1966, major-league baseball arrived, bringing with it the city's first superstar, the legendary Henry Aaron.

Then, the ultimate breakthrough: Atlanta became an international city in the 1990s, hosting the Summer Olympics, two Super Bowls, and five World Series.

On the pages that follow, you will see why baseball has been called "a measure of time." Paul Crater's book will show you the faces of Atlanta's "boys (and girls) of summer" and the places where they played.

But these images transcend baseball. In them, you will find success and failure, dreams and despair, humor and drama, legends, and—above all—nostalgia. You will see how baseball has helped shape Atlanta's identity.

That identity was greatly enhanced by the Braves recent streak of 14 consecutive postseason appearances—an unprecedented achievement. But those 14 years represent only about 10 percent of Atlanta's baseball history.

As you turn these pages, think of the impact that this game has had on Atlanta's economy, its tourism, its media, and even on the look of the city itself. Think of the impact this game has had on Atlanta's image to the rest of the world.

As a broadcaster, it is my job to provide a daily narration to this ongoing history. When the Braves are at home, my first words are usually, "Welcome to Turner Field." Spend some time with this outstanding photographic collection, and you'll see how we got there.

—Pete VanWieren
Atlanta Braves

ACKNOWLEDGMENTS

There are many people who deserve special praise for the assistance they gave me in producing *Baseball in Atlanta*. From the Kenan Research Center, I would like to thank Mike Brubaker, Chuck Raper, Lindsay Joyner, Laura Zimmerman, and Perry Craine for their help with research and captions. I would also like to thank Stacy Braukman for her help in editing the text. Special appreciation goes to Carolyn Serra at the Atlanta Braves Museum and Hall of Fame and Karen Jefferson and Trashinda Wright at the Robert W. Woodruff Library of the Atlanta University Center for granting me permission to publish images from their collections. I would like to give my final thanks to former Atlanta Crackers star Buck Riddle for his help in identifying players and for his reflections on his playing days in Atlanta.

—Paul Crater
Senior Archivist
Atlanta History Center

INTRODUCTION

When someone says the words "baseball" and "Atlanta," what comes to mind? If you're like most people, you probably think immediately of the Atlanta Braves. And why shouldn't you? The Atlanta Braves are one of the most successful franchises in Major League Baseball, with 16 playoff appearances, 5 National League pennants, and one world championship. When you consider that, according to a recent ESPN poll, the Braves have played in Atlanta for as long as the average baseball fan has been alive, this association seems even more solid.

The Braves, and all of the exciting moments they have provided, are of course a vital part of Atlanta's baseball heritage, but there is much more to it than Bobby Cox and the tomahawk chop. *Baseball in Atlanta* completes the story, presenting images of players, teams, and ballparks that will fascinate the sports enthusiast and stir memories of those who were around to witness their glory.

The first two chapters focus on the people and events during the 100 years that elapsed between the first recorded baseball game in the city's history and the Atlanta Braves' inaugural game in 1966. Chapter one focuses on images of collegiate teams in the Atlanta region and amateur teams in leagues throughout the city, which illustrate the widespread popularity of the sport and its traditions. Photographs of Atlanta's home-produced talent illuminate the area's contribution to baseball.

Chapter two explores the legacy of the Atlanta Crackers, "the New York Yankees of the minor leagues," who won an amazing 17 league championships. The Crackers played at Ponce de Leon Park—the gem of the Southern Association—which hosted Sunday doubleheaders and where a Magnolia tree grew in center field. The Crackers featured an array of exciting ballplayers who thrilled generations of fans. In addition to championship baseball, Atlantans also saw the most famous players in history take the field at "Poncey," including Babe Ruth, Jackie Robinson, and Mickey Mantle.

Yet another story is that of the Atlanta Black Crackers. Professional baseball in Atlanta, as in the nation, was once a segregated sport. This one-time member of the Negro Leagues barnstormed the South for more than 20 years, providing excitement and thrills wherever they went.

The final chapter spotlights the Braves, from their birth in Boston through the glory years of the 1990s. From Hank Aaron's home-run record, Ted Turner, and Eddie Mathews, to the 1995 World Championship, Chief Noc-A-Homa, and Dale Murphy, the images in *Baseball in Atlanta* document the dazzling accomplishments, wild characters, and exceptional players of the Atlanta Braves.

THE AMATEURS

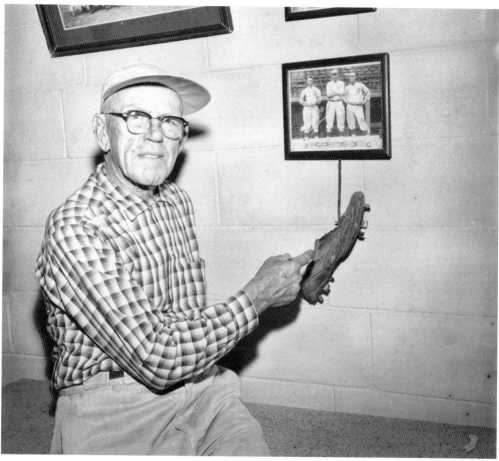

Pictured is one of Georgia's all-time baseball legends, George Napoleon "Nap" Rucker of Roswell. Enticed by newspaper stories promising a fortune for men able to play the game, Rucker dropped out of school and became a pitcher in the minor leagues. His trek to fame began with the Atlanta Crackers in 1904, and he later advanced to the major leagues in 1907 with the Brooklyn Superbas, who later became the Brooklyn Dodgers. A perennial league leader in innings pitched and strikeouts, Rucker once threw a no-hitter. Legendary baseball manager John McGraw called him the best left-handed pitcher of his era. After retiring from baseball in 1916, Rucker became a scout for the Dodgers and later the Atlanta Crackers. He settled back in his hometown of Roswell, where he served as mayor during the 1930s. Rucker was the third professional baseball player (behind Ty Cobb and Luke Appling) to be inducted into the Georgia Sports Hall of Fame.

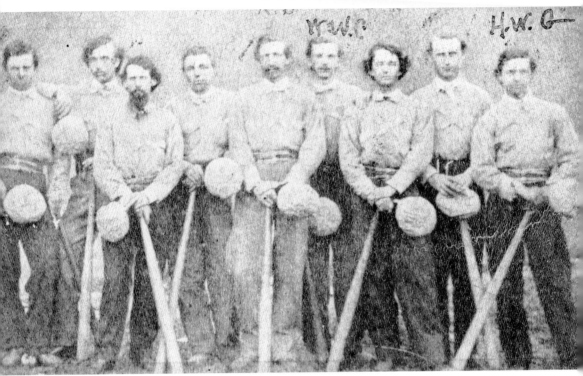

Known primarily for his advocacy of the idea of the "New South," journalist and orator Henry W. Grady (far right) was also a spirited athlete and avid baseball fan. In 1872, during his early newspaper career, Grady's baseball team defeated the previously undefeated Atlanta Osceolas by bringing in a New York pitcher who delivered a one-hit shutout. Although there was no rule banning Grady from slipping in a substitute pitcher, the Osceolas players were so appalled that many quit the team, bringing an end to the Osceolas. While editor of the *Atlanta Constitution* in 1881, Grady insisted the newspaper include game results and news regarding the Atlanta Tullers and other baseball organizations. The growing baseball fever of the 1880s led to the creation of a professional league in the South—the Southern League—which consisted of eight teams and was established in 1885, with Grady serving as president.

AMATEURS

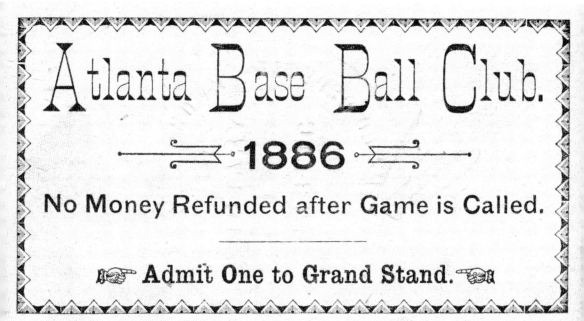

Atlanta Base Ball Club.

— 1886 —

No Money Refunded after Game is Called.

☞ Admit One to Grand Stand. ☜

Was it perhaps because the city of Atlanta lacked an identity in 1886 that it named its baseball team the "Atlanta Atlantans?" Probably not, but that was the name of Atlanta's team when it joined the Southern League in 1885. Successive teams from Atlanta were called the Firecrackers, the Windjammers, the Firemen, and finally, the Crackers.

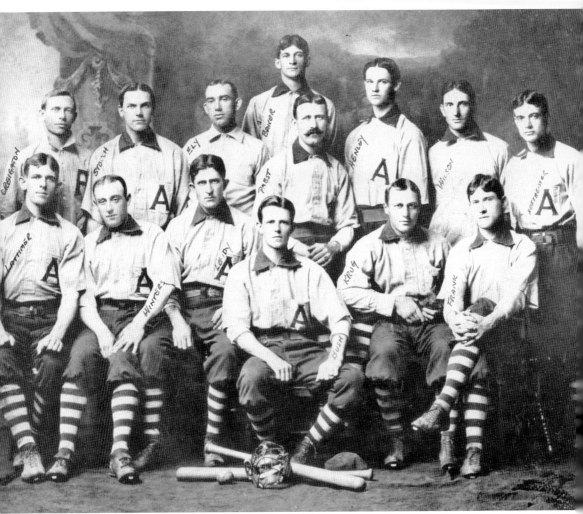

The Atlanta Firemen joined the newly formed Southern Association in 1902 after the Southern League folded in 1899. The name of the team was changed to the Crackers in 1903. Ed Probst (center with mustache) was manager. Weldon Henley (standing, third from right) was an outstanding pitcher, winning 20 games and advancing to the big leagues the following season. Previously, Henley was captain of the Georgia Tech baseball team.

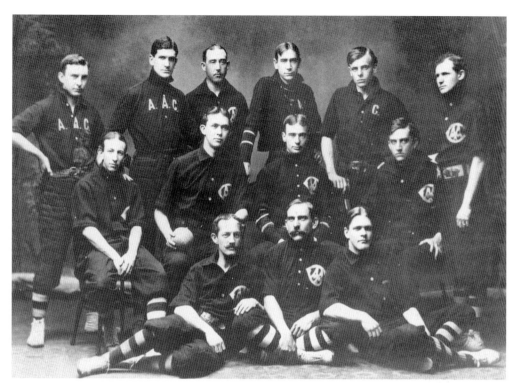

The men of the Atlanta Athletic Club softball team were involved in many sports through their membership in the prestigious exercise and social club formed in 1898. Softball games took place at Ponce de Leon ballpark whenever the minor-league Atlantans had away games, and in 1908, the directors bought a box for club members' viewing. Participating in other sports such as basketball, golf, and tennis, the club competed against other city teams, including Marietta, Acworth, and Cartersville.

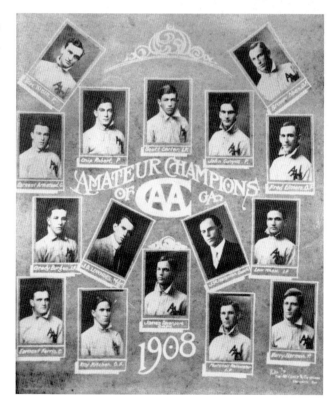

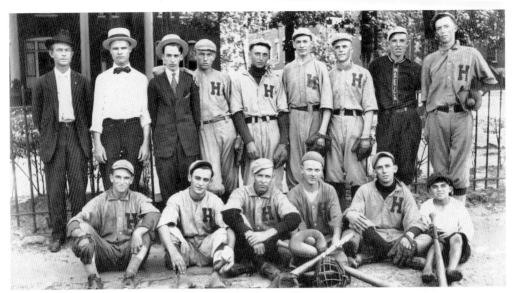

A small city just south of bustling Atlanta, the city limits of Hapeville measured only one square mile. Incorporated in 1891 with the extension of the Central of Georgia Railroad, Hapeville grew as a suburban town with promising industry. At the same time, recreational sports became increasingly popular, leading to the creation in 1913 of the Hapeville baseball team, which competed in the Manufacturers League against similar small towns near Atlanta such as College Park and East Point.

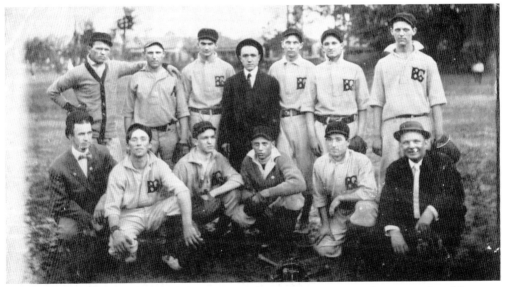

Baseball became a hugely popular sport during the first part of the 20th century. In addition to leagues featuring professional and municipal teams, baseball leagues representing small businesses and large corporations also thrived in Atlanta. The Beck and Gregg Hardware Company, located on Marietta Street in the heart of downtown Atlanta, was among the earliest representatives of companies sponsoring their own baseball teams.

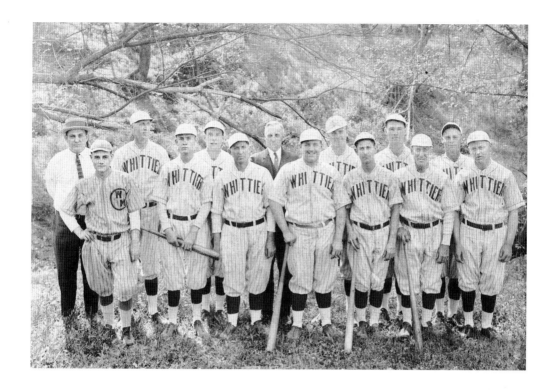

Workers at the Whittier Mill in Atlanta eagerly participated in baseball and other activities. A textile mill with an attached village, Whittier Mills opened in 1896. Mill owners provided cottages, settlement houses, schools, and recreation facilities for residents. In an attempt to foster solidarity among workers, mill owners financed a company baseball team and ballpark to compete against other mills in the Atlanta area. When Whittier Mills was sold in 1952 to Scott Dale Industries, many houses were moved to the former baseball grounds to create larger lots. By 1970, the mill was forced to shut down due to competition from overseas companies and a shortage of textile workers.

BASEBALL IN ATLANTA

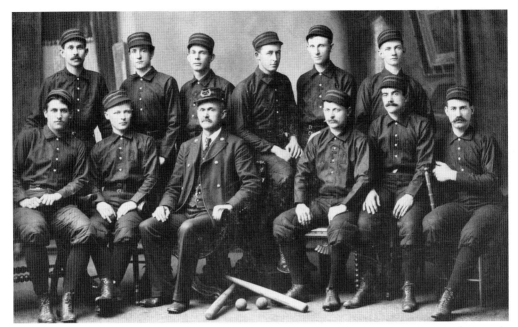

This is the official portrait of the Atlanta Fire Department in 1898. As a testament to their pride in winning the city baseball championship that year, the squad posed with bats and balls. The team was led by Walthall R. "Cap" Joyner (first row, third from left). Joyner was chief of the fire department from 1885 to 1906. He resigned when he was elected mayor of Atlanta.

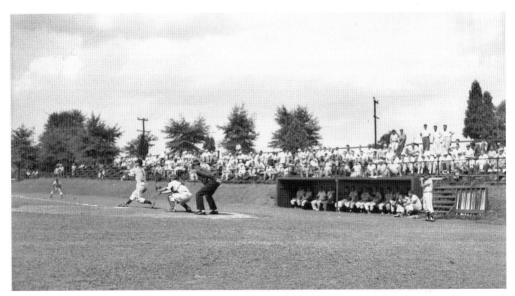

Atlantic Steel was a staple of Atlanta's industrial base for decades, employing more than 2,000 people during its peak years of production. The company fielded highly competitive amateur baseball teams from the 1920s to the 1950s, which became perennial contenders in the City League. This league also included teams from East Point, College Park, Fort McPherson, Georgia Railway and Power Company, and the Knights of Columbus.

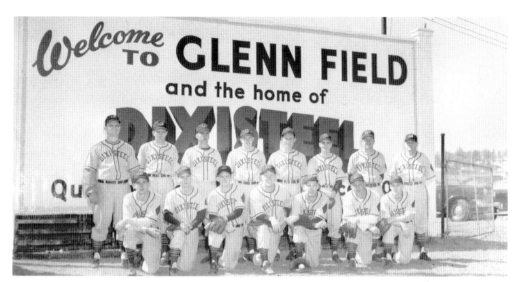

Players were recruited to the Dixie Steel roster and were offered jobs. The more educated players were placed in supervisory positions, while others performed blue-collar jobs. Teams like Dixie Steel provided a showcase for amateur players to help them garner attention from professional teams. Games were played across the street from the mill at Glenn Field, named after former Atlantic Steel executive T. K. Glenn.

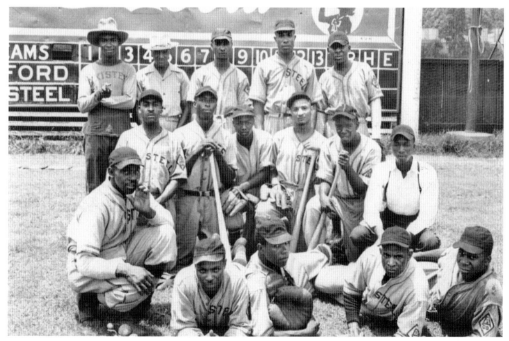

Like virtually all institutions in the city, Atlantic Steel operated on a segregated basis, and baseball teams were not exempt. This team worked inside the plant's hoop mill alongside their white counterparts, but played ball separately. Baseball remained vital to the company's culture throughout the 1950s.

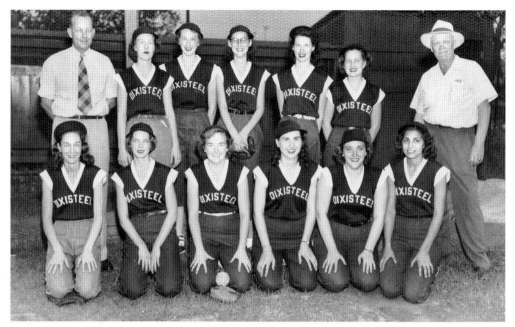

With a shortage of available men during World War II, women began to fill jobs at the company. Soon after, women's softball teams formed.

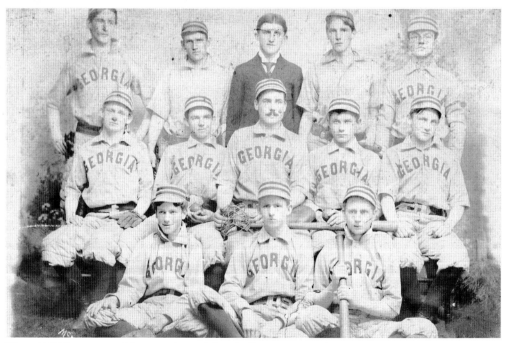

The 1895 University of Georgia (UGA) baseball team entered its ninth season of play managed by "Hustlin' " Hughie Jennings. The Bulldogs played on the northwest campus on a field that in 1896 was enlarged to become Herty Field. Jennings managed four seasons at UGA and finished in 1899. He went on to manage Ty Cobb and the Detroit Tigers from 1907 to 1920.

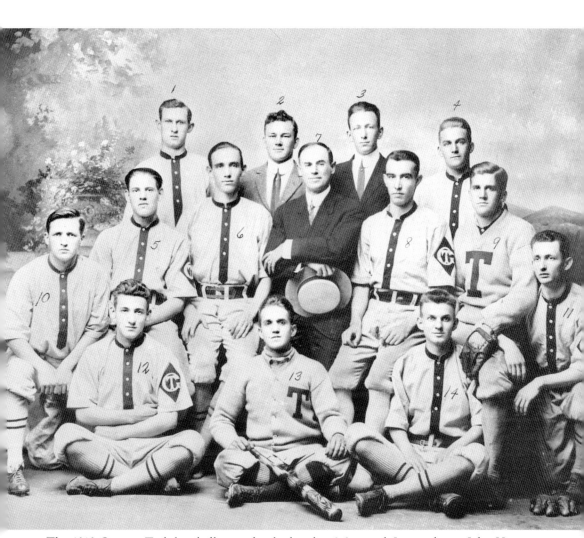

The 1913 Georgia Tech baseball team finished with a 9-8 record. Its coach was John Heisman (center, holding hat). The Heisman Trophy, awarded each year to the nation's best college football player, is named for Coach Heisman, who was hired to coach the baseball, basketball, and football teams at Georgia Tech in 1904. As football coach, Heisman established a 102-29-7 record over 16 seasons. His teams in 1915, 1916, and 1917 went undefeated. He coached the baseball team through 1917.

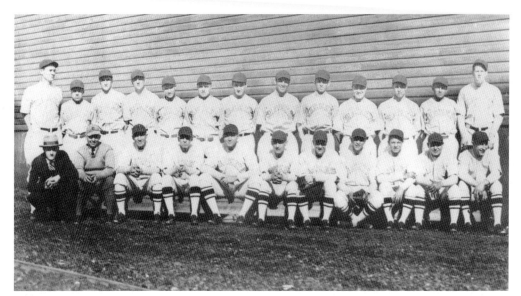

The 1926 Georgia Tech team put together a record of 24-4-1, one of the best in the country. Tech was a member of the Southern Conference that year, although the conference did not officially recognize baseball as a sport until many years later. In subsequent years, the school affiliated with the Southeastern Conference, Metro Conference, and in 1978, the Atlantic Coast Conference. Georgia Tech baseball teams have traditionally been successful and have produced outstanding professional ballplayers.

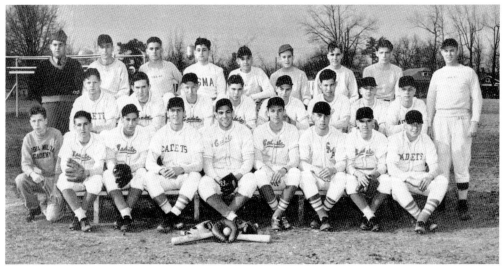

The baseball squad at the Georgia Military Academy (GMA) is pictured here in 1942. The team competed against other private high schools as well as against public schools. The GMA was founded in 1900 as a military boarding school for boys and remained as such until 1966, when military training was discontinued. The school was renamed Woodward Academy after its founder, Col. John Charles Woodward.

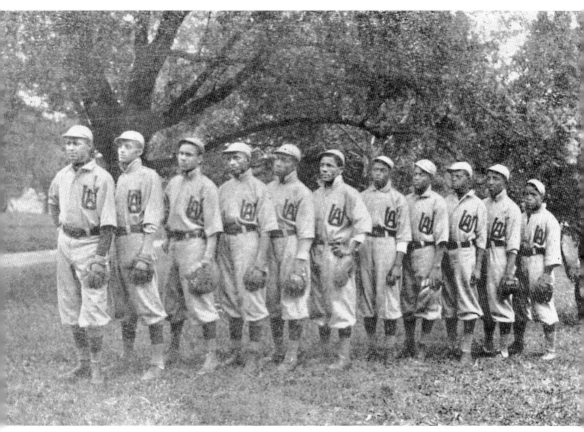

This Atlanta University baseball team portrait was taken around 1900. In the early 1880s, Atlanta University competed against Clark University and other teams at the Atlanta University Center (AUC), including Atlanta Baptist Seminary (later Morehouse College) and Morris Brown College. The teams would each play six games, two games against each opponent. The winner received a silk pennant at the end of the season. Baseball was the first sport played at several of the AUC institutions, and many players were recruited to play with the Atlanta Black Crackers in the 1920s and 1930s. (Atlanta University Photographs, Robert W. Woodruff Library of the Atlanta University Center.)

Marist is a private Atlanta Catholic school founded in 1901 as Marist College. The named was changed to Marist School in 1962. These two images of the Marist College baseball team from around 1910 indicate that baseball has played an important role at the institution since its inception. Indeed Marist has an outstanding tradition of athletics, and *Sports Illustrated* deemed its athletic program one of the best in the country. Former Marist baseball stars populate teams in colleges and universities throughout the country, and even the sons of former Braves players Hank Aaron and Ernie Johnson are counted among its graduates.

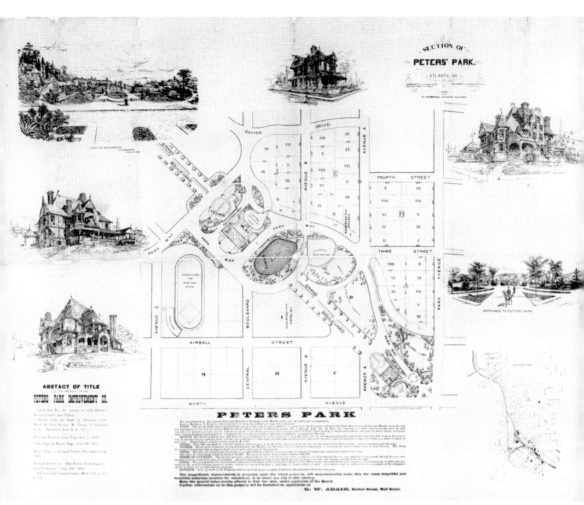

Atlanta's professional baseball teams played at five different sites between 1885 and 1907. One of the early proposed sites was Peters Park, located at the corner of North Avenue and Peachtree Street. The park's developers built a new baseball diamond, including bleachers and grandstands for spectators in the spring of 1889. Atlanta was required to play all of their games on the road until the park was finished, but the Southern League suspended play for the year before construction was over. The park was also supposed to be developed as a residential area, but when that failed to materialize, the Georgia Institute of Technology purchased the 200-acre site. Southern League games were later played at Brisbane Park, located in South Atlanta at Cumley, Glenn, and Ira Streets, and on the Athletic Grounds, built by Consolidated Railway.

Planners originally intended for Piedmont Park to be used by members of a nearby country club to race their horses. In the early 1900s, baseball diamonds were developed in the park, and soon thereafter, the Atlanta Crackers began playing their home games there. In 1909, the City of Atlanta hired the Olmsted Brothers Company, prominent landscape architects (and sons of Frederick Law Olmsted), to develop a master plan for the park. While that plan was never fully implemented, the park continued as a primary area for recreation. Over the course of the next century, Piedmont Park played host to little-league games and countless baseball and softball games in adult recreational leagues.

AMATEURS

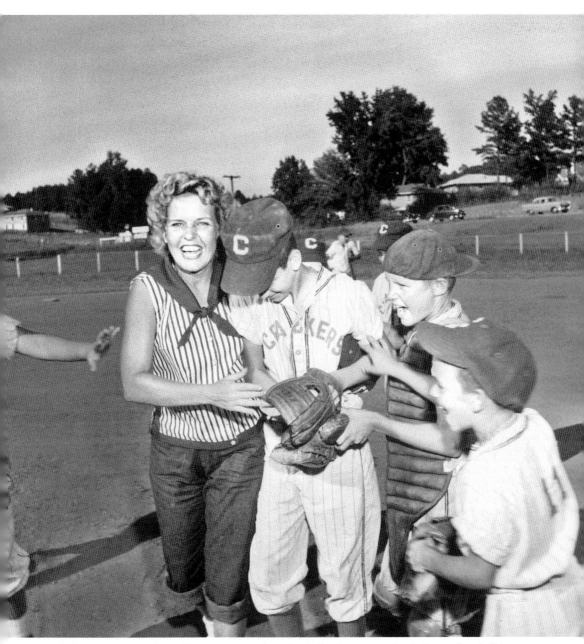

Little-league manager Peggy Rogers congratulates her kids after a game. Little-league baseball became a nationwide phenomenon in the late 1940s and early 1950s. In the Atlanta area, organizations like the Northside Youth Organization, the Cascade Youth Organization, the East Cobb Baseball Program, and various Dixie Youth leagues foster competitive environments and provide boys and girls the opportunity to play the game on an organized level. The East Cobb Baseball Program, located north of Atlanta in the city of Marietta, is one of the finest youth leagues in the country. It operates a multimillion-dollar facility and has produced dozens of collegiate and professional baseball players over the last 20 years.

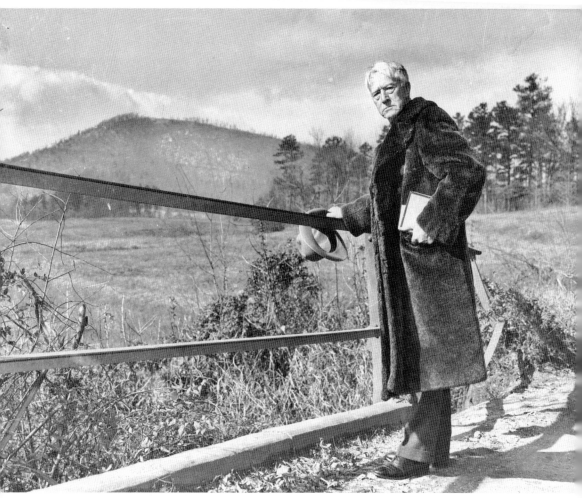

Standing in front of Georgia's Kennesaw Mountain is Judge Kenesaw Mountain Landis, the first commissioner of baseball, who helped to restore public trust in the game after a scandal to fix the 1919 World Series by members of the Chicago White Sox. He was named after the Georgia mountain, which was the site of a major Civil War battle during General Sherman's Atlanta campaign (and where his father, an Ohio surgeon and soldier, had been seriously wounded). He misspelled Kennesaw, however, dropping one "n." He served as commissioner until his death in 1944. The major league's Most Valuable Player awards are named the "Kenesaw Mountain Landis Awards" in honor of the former commissioner.

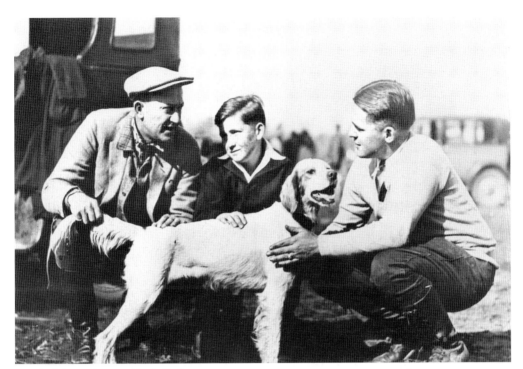

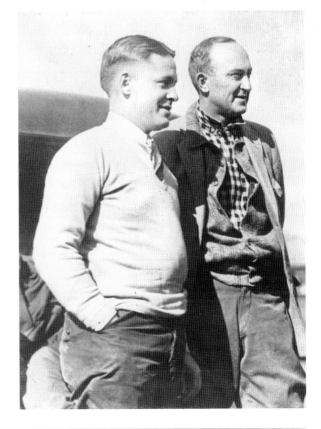

Baseball legend Ty Cobb (left), his son Herschel, and golfing legend Bobby Jones are pictured during one of Cobb's many hunting excursions. Cobb was born in Narrows, Georgia, and was among the most accomplished players in the history of the game. After a 22-year career, Cobb retired to his home in Augusta. While Cobb and Jones were the best in their respective sports, the two seemed unlikely companions. Cobb did not get along with many people, both in and out of baseball, and was regarded by many as abusive and coarse. Although Jones also had a nasty temper, he conquered it at an early age and is remembered as a gentleman. A probable connection between the two was their mutual friendship with Coca-Cola executive Robert W. Woodruff.

Ernie Harwell began broadcasting Atlanta Crackers baseball as a side venture in 1943. After serving in the marines, he came back to Atlanta in 1946 and resumed his play-by-play duties with the club. Home games were sent over the airwaves as live feeds from the booth, while road games were announced in the studio of WATL. Harwell received wire reports of the game and re-created the action with studio sound effects.

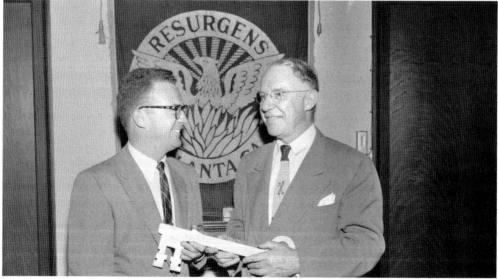

Atlanta mayor William B. Hartsfield presents the key to the city to broadcaster Ernie Harwell. Harwell was born in Washington, Georgia, and attended Emory University. His announcing career with the Crackers ended in 1948, when he was traded to the Brooklyn Dodgers for catcher Cliff Dapper, marking the only time in baseball history when an announcer was traded for a player. Harwell became famous as the voice of the Detroit Tigers and received several national honors for his work.

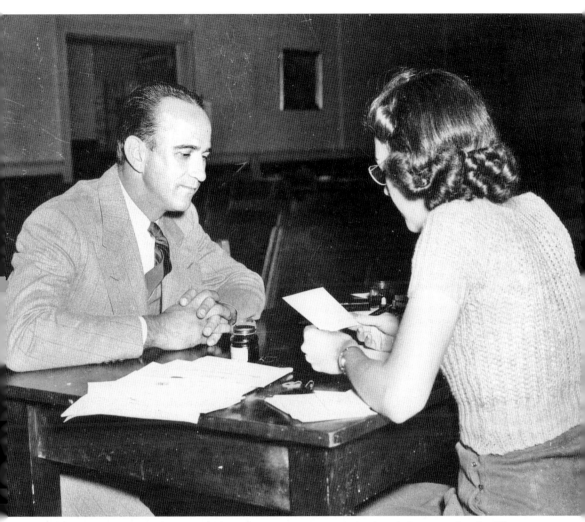

Luke Appling, shown registering for military service in 1940, played shortstop for the Chicago White Sox for his entire career in the majors. He was an all-star for seven years, had a .310 lifetime batting average, and was elected to baseball's Hall of Fame in 1964. Appling played baseball at Oglethorpe University in Atlanta for two years, and then played for the Atlanta Crackers in 1930. He served as a batting instructor for the Atlanta Braves in the 1980s. During an old-timers game in 1982, the 75-year-old Appling hit a 250-foot home run off former Brave Warren Spahn. Appling was nicknamed "Old Aches and Pains" for his physical ailments and his grousing about infield playing conditions.

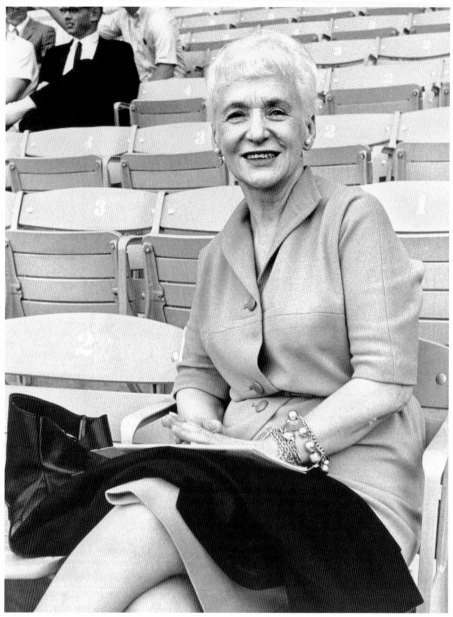

Beginning in 1934, Pearl Sandow attended every professional baseball game in Atlanta for 55 years, except one—when her mother had a stroke. She attended more than 1,850 Atlanta Crackers games and 1,889 Atlanta Braves games. She was involved in an accident in 1990 and could no longer travel to the ballpark. She was often the first fan to arrive at the game and rarely missed batting practice. In 1975, the Braves rewarded her with a lifetime pass and a night in her honor at the stadium. On May 12, 2002, the Braves brought her to Turner Field for the first time to celebrate her 100th birthday and named her team captain for the day. Her highest recognition came in 1989, when the National Baseball Hall of Fame enshrined her in the fans' section with a statue in her likeness. Pearl Sandow died on April 17, 2006, at the age of 103.

2

THE ATLANTA CRACKERS

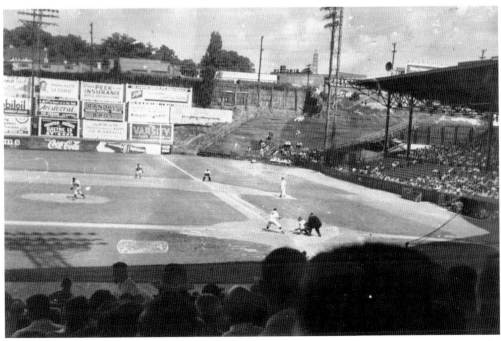

An unidentified pitcher for the Detroit Tigers delivers during an exhibition game against the Atlanta Crackers in 1952 at Ponce de Leon Park. The Tigers won the game in a slugfest, 10-9.

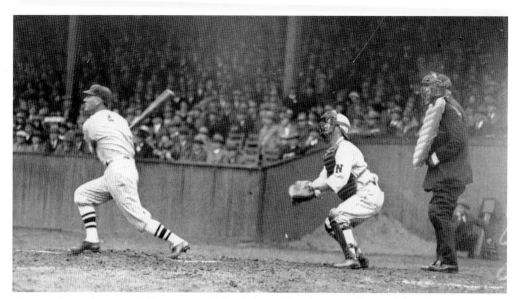

Among the earliest available images of the Atlanta Crackers are those of their best players. In 1925, outfielder Wilbur Good set team records for the most hits (236) and total bases (343). His .379 batting average led the league and propelled the Crackers to the Dixie Series, where they lost to Texas League champion, Fort Worth. After his playing days, Good managed the Crackers for two years in the late 1920s.

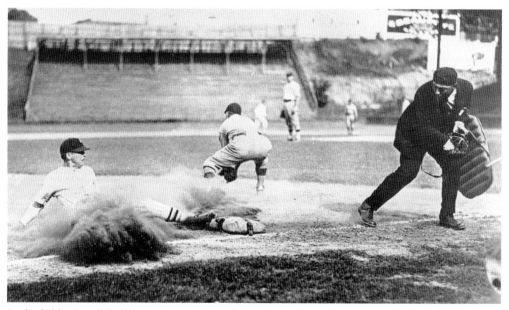

Right fielder Frank Zoellers was a consistent hitter throughout his career in Atlanta, batting over .300 in three of his four years. He played a crucial role in the Crackers' championship season in 1925, but was traded the following year in a deal that sent second baseman Tony Lazzeri to the New York Yankees and their "Murderers Row" of Hall of Fame sluggers. Zoellers returned to Atlanta in 1927 and played two more years with the Crackers.

THE ATLANTA CRACKERS

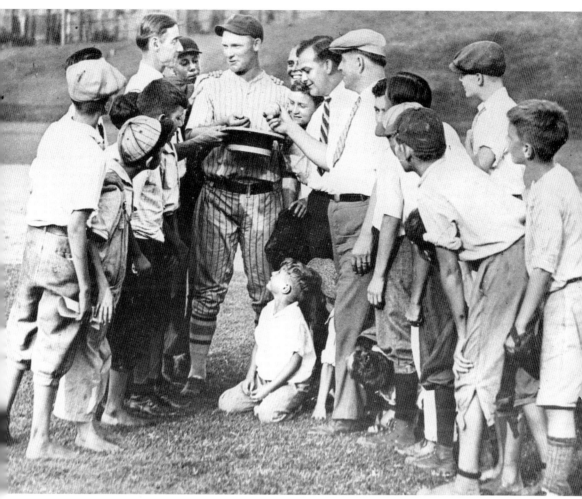

Fan favorite Nick Cullop soaks up the limelight during the 1925 season, when he led the Southern Association with 30 home runs and finished second in RBIs with 139. Minor-leaguers were generally not well compensated for their services, but fans often showed their appreciation to popular players by passing around a skimmer hat in the stands to collect money for them, as shown here. Cullop suffered a horrible tragedy that year on July 4 when his young son fell from an apartment window and was killed. His skill and courage in the face of adversity solidified his place in team history. After a brief stint in the major leagues, the minor-league legend returned to the Crackers for the 1928 and 1929 seasons. A great hitter but poor in the field, Cullop had a career batting average of .312 and had 2,670 hits with nine different teams. He finished his 25-year career as the all-time minor-league RBI leader and is currently sixth all-time in home runs with 420.

Leo Durocher played for the Crackers in 1926. He played 130 games at shortstop for the team and hit .238. Durocher never hit for average or power, but was quite adept in the field. He refined his skills while playing for Atlanta and praised the invaluable coaching he received from the Crackers coaching staff. Durocher made his name as a manager, posting over 2,000 wins in 22 seasons and one World Series championship.

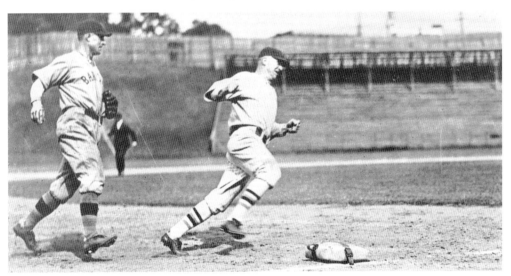

J. Carlisle "Red" Smith rounds third base against the Birmingham Barons. In 1924, Smith scorched Southern Association pitchers with a .385 average. He played for nine seasons in the major leagues but played out his career in the minors. He was traded to the Boston Braves in 1914 and led the team to a remarkable season, culminated by a victory in the World Series over the Philadelphia Athletics.

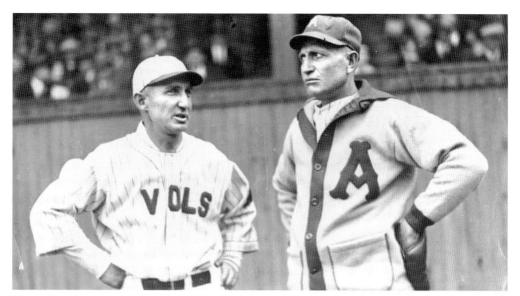

Jimmy Hamilton, manager of the Nashville Volunteers, and Bert Niehoff, manager of the Atlanta Crackers, chat before a game in 1926. The Volunteers were charter members of the Southern Association in 1901 and continued as a franchise until 1961, when the league was disbanded. Former Vols include Kiki Cuyler and Waite Hoyt, both of whom were inducted into the National Baseball Hall of Fame.

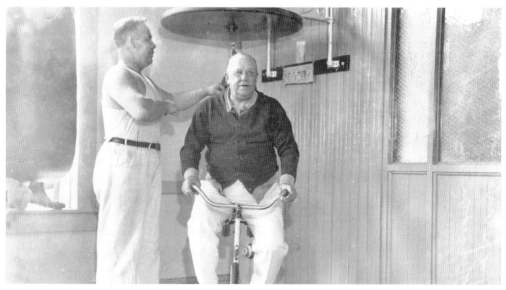

Atlanta Crackers team president Wilbert Robinson (1933–1934) works out on a stationary bicycle under the supervision of team trainer Bill Daly. Robinson came to Atlanta after a stellar career managing the Brooklyn Dodgers. His friend and former New York Yankees owner Col. Tillinghast L. Huston of Butler Island, Georgia, persuaded Robinson to come to Atlanta as team president in 1933. Robinson passed away the following year and was replaced by Earl Mann, a rising baseball executive.

Otis Earl Mann became president of the Atlanta Crackers in 1934 and remained in control of the team until 1959. He is praised by baseball historians as one of the most successful operators of minor-league clubs in the history of the game. His teams won 10 pennants in 25 years, won more games than any other team in the Southern Association, and consistently led all minor-league cities in attendance.

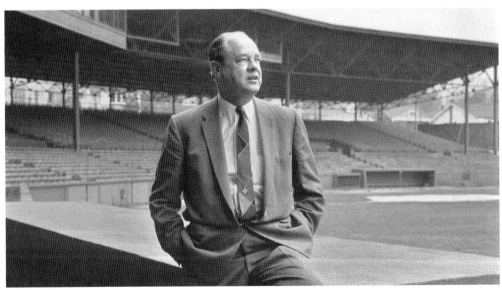

Mann began his career with the Crackers selling peanuts and popcorn in the stands as a boy and was promoted to club secretary in 1927. He left the organization in 1929 and served as general manager for minor-league ball clubs in North Carolina, Georgia, Connecticut, and West Virginia. Each of his teams won a pennant under his leadership. He returned to Atlanta in 1934 and became owner of the team in 1949.

Earl Mann (right) and Chattanooga Lookouts owner Joe Engle suit up as managers in a game at Poncey. Promotional activities like these were a tradition at minor-league ballparks and were important in attracting fan interest and enthusiasm. The two owners had a friendly rivalry, which included opening-day attendance contests that saw the loser receiving a bronzed horse's rear as a trophy.

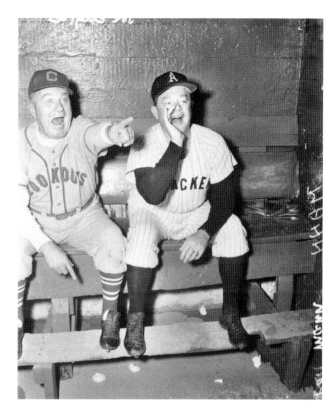

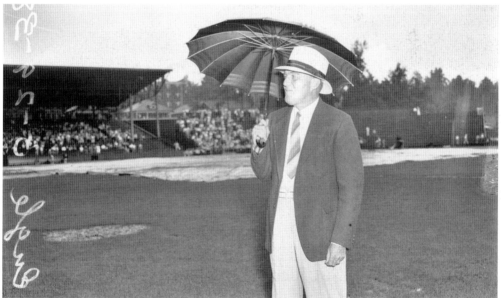

Chattanooga Lookout owner Joe Engle is seen during a rain delay at Ponce de Leon ballpark 20 years earlier, in 1938. Known as "the Barnum of the Bushes," Engle's stunts included signing a 17-year-old female pitcher and trading a player for a 25-pound turkey. "I always try to look on the light side of things," Engel once said.

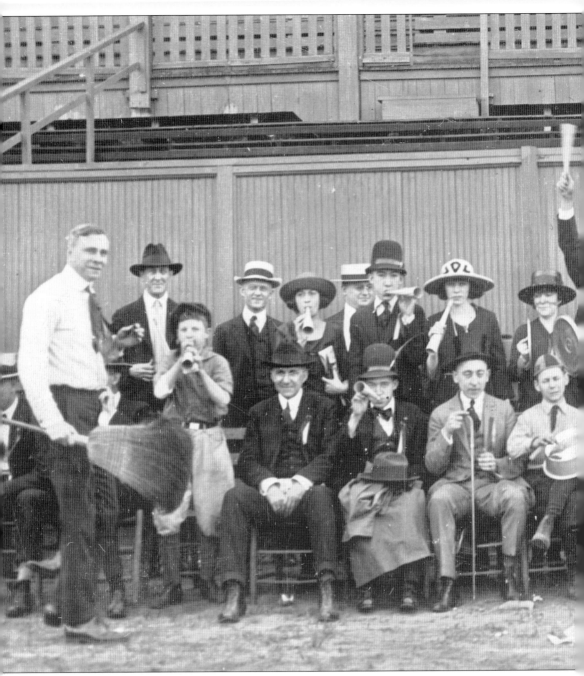

The "Royal Rooters" was the name given to fans of the Boston Red Sox who sang songs, blew horns, and banged pots and pans to cheer on their team and to distract their opponents. Fans of other sports teams apparently adopted the moniker. In 1903, the *Southern Sportsman*, the official organ of the Southern Associates, used the term to describe fans of the Atlanta Crackers, pictured here on the field at Ponce de Leon Park. Despite the rather well-heeled appearance of Royal Rooters, the crowds at Crackers games were quite diverse. There were people from the wealthier north

THE ATLANTA CRACKERS

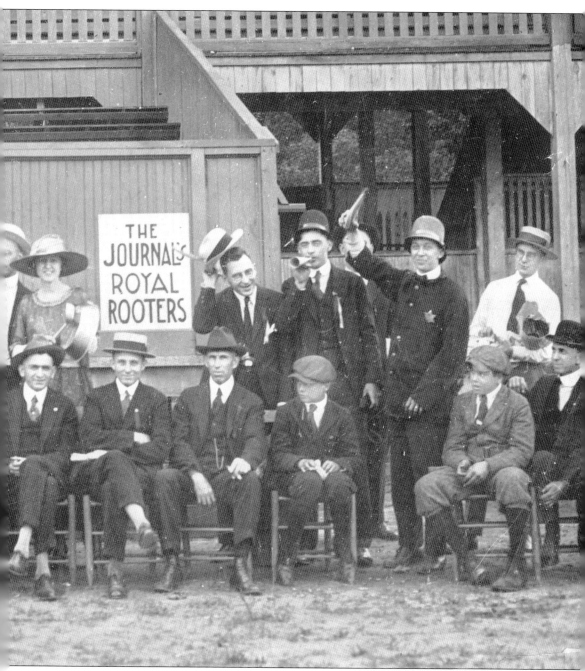

side of Atlanta who came to be seen and fans of both races from the south side who often sat in the outfield bleachers, where rowdy behavior like gambling and whisky drinking was allowed. Earl Mann made frequent requests to Atlanta mayor William Hartsfield to attend games but was always turned down. Hartsfield once said, "Baseball fans are made up of filling station operators, taxicab drivers and garbage collectors." Elaborating further, he admitted, "I don't like to go to baseball games. They boo me."

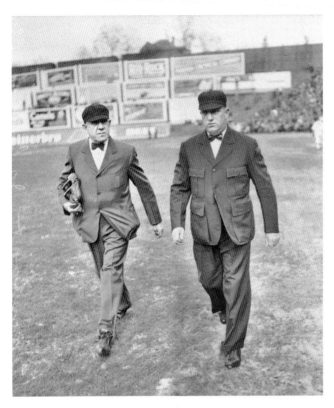

Harry "Steamboat" Johnson (left) and an unidentified official take the field to umpire a game at Poncey. Johnson umpired games from 1909 to 1946. In Johnson's era, umpires were often harassed and assaulted for disputed calls against the home team. One of his more harrowing episodes occurred in Atlanta in 1919. After he ejected two Crackers players, fans pelted him with bottles in the back and head before he escaped to the dressing room. Umpires announced the batting orders in the days before loudspeakers, and Johnson's powerful voice reminded people of a Mississippi steamboat. The nickname stuck.

THE ATLANTA CRACKERS

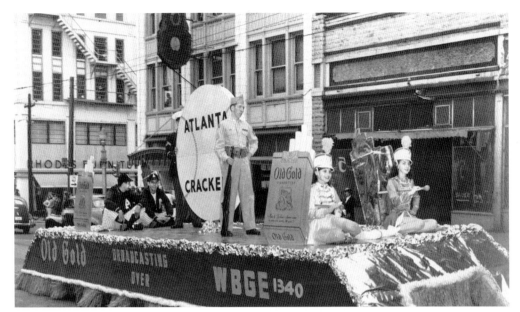

Atlanta Crackers games were broadcast on several local radio stations, including WBGE, an outlet whose signal transmitted from the basement of the Georgian Terrace Hotel, which was located a short distance from Ponce de Leon Park. The station carried the games in the late 1940s and early 1950s and included pregame and postgame specials.

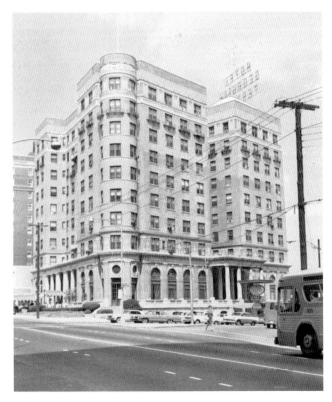

The Georgian Terrace Hotel provided accommodations to the Crackers' visiting opponents. Players and coaches often walked the few blocks between the hotel and the stadium, sometimes catching a meal at the various restaurants and diners located on Ponce de Leon Avenue. The hotel is listed on the National Register of Historic Places and hosted the world-premiere reception for the movie *Gone With the Wind* in 1939.

BASEBALL IN ATLANTA

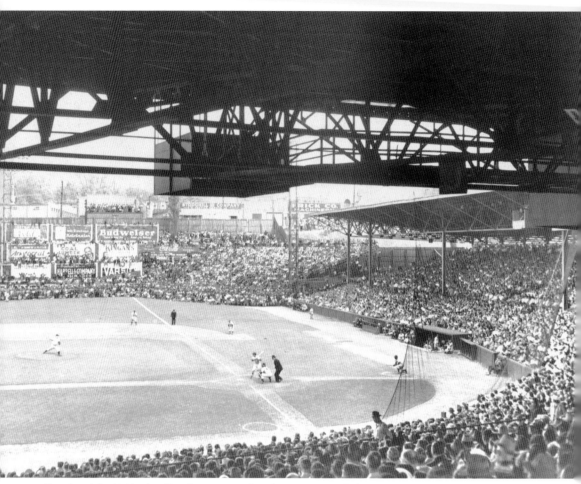

On April 8, 1949, the Crackers opened a three-game exhibition series against the Brooklyn Dodgers. It was the first-ever integrated professional contest in Atlanta, and it drew the largest attendance in franchise history. More than 15,000 fans attended the opener, mostly to see Georgia native Jackie Robinson, the man who had integrated Major League Baseball two years earlier. On the day this photograph was taken, 25,221 fans filled the stands and lined the outfield walls to catch the finale. Poncey was still a segregated venue, so most of the estimated 13,885 African Americans in attendance sat along the tiered right-field signs, in the center-field bank, and along the outfield wall. The left-field stands were filled three hours before the first pitch. The stadium had only once held a crowd larger than this. The Baptist World Alliance had assembled nearly 40,000 in 1939.

THE ATLANTA CRACKERS

Atlanta was still a thoroughly segregated city in 1949, and a slightly tense atmosphere surrounded the event. Earl Mann received several threatening phone calls from members of the Ku Klux Klan, who predicted violence if Robinson took the field. Correspondents from African American newspapers came to town, as did writers from *Time* magazine, *Life* magazine, and the beat writers who covered the Brooklyn Dodgers. The series unfolded without any incidents, however, and both Robinson and Roy Campanella, another black player for the Dodgers, received largely favorable responses from the crowd both at the plate and in the field. When a reporter asked Robinson if the attitude of the fans toward him and Campanella any different in Atlanta than elsewhere, he replied, "Yes, it's better."

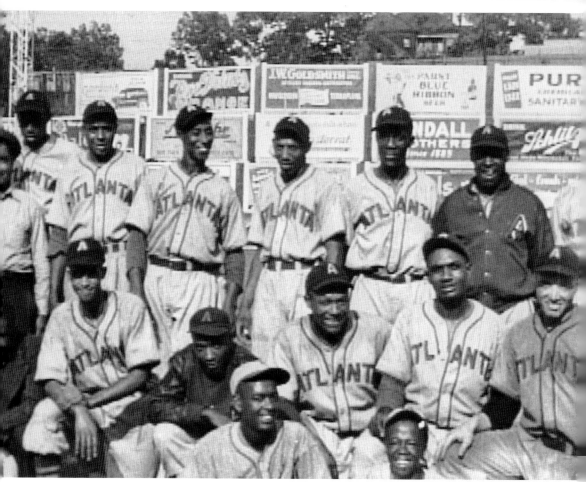

Baseball at the professional level was played on a segregated basis throughout America until 1947. When Jackie Robinson broke the color line that year, it triggered the eventual demise of the Negro leagues and the teams that composed them. Atlanta's Negro-league team was the Black Crackers, and included the best players from Morehouse College, Morris Brown College, and Clark College. The Black Crackers were charter members of the Negro Southern League, whose teams were generally considered to be farm teams for the Negro National League. The photographs on the next three pages are images of an unidentified Black Crackers game at Ponce de Leon Park during the late 1930s. The players depicted are also unidentified to the author.

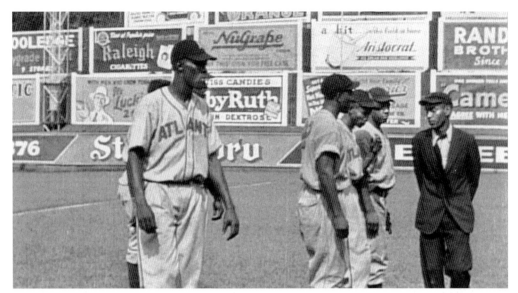

In Atlanta, the Black Crackers played some of their home games at Ponce de Leon Park on days when the white Crackers were on the road. The team owners negotiated with Earl Mann to use the field for games, but they were not permitted to use the facilities to shower or change clothes afterwards. Often their uniforms came from colleges or were hand-me-down jerseys from the white Atlanta Crackers.

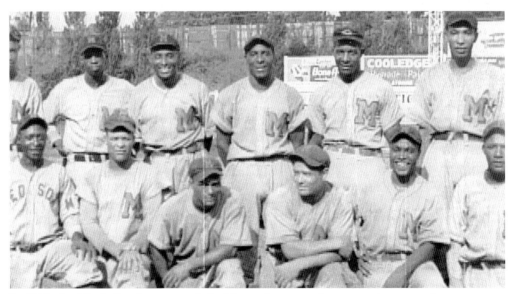

In 1938, the Black Crackers entered the Negro American League and competed against more established teams such as the Homestead Grays, the Memphis Red Sox, and the Kansas City Monarchs. The Black Crackers finished with a 12-4 record in the second half of the season to qualify for the pennant against the Red Sox; however, the championship series was cancelled by the commissioner after scheduling disagreements between the two clubs. This was the only year on record in which the Black Crackers competed in this advanced league.

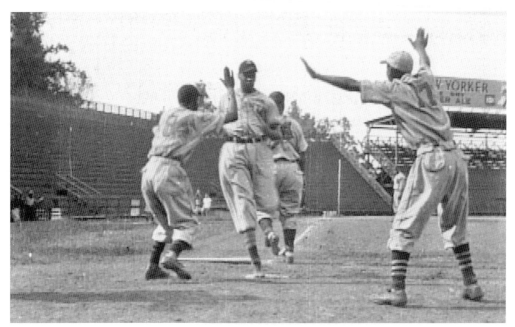

White minor-league players didn't make much money, and black players made even less. Negro Southern League franchises got by on whatever income they could generate at home games. To supplement their income, the Black Crackers went out on the road after school closed for the summer and played other Negro League teams in Georgia and throughout the Southeast. The team usually consisted of 12 to 18 players who traveled by bus, playing 7 to 10 games a week. Players sometimes slept three or four to a room at a hotel, a YMCA, or in the house of someone who offered room and board in exchange for rent.

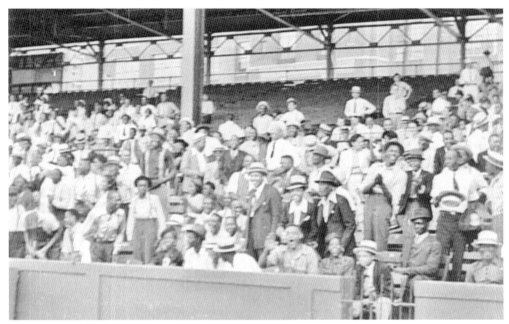

On days when the Black Crackers played at Ponce de Leon Park, people of both races turned out to watch the games. The rule on segregated seating was temporarily abolished for these games, and black attendees could sit along the baselines and outside their regular confines in the left-field bleachers. Black newspapers like the *Atlanta Daily World* advertised upcoming games and published stories about the team that included league standings. By most accounts, baseball was the most popular sport in America during the 1930s and 1940s, and whether they were part of an organized league or not, the Black Crackers were supported at home and on the road on their barnstorming tours in the South.

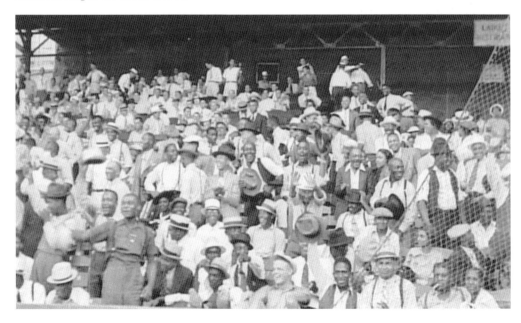

These two images were taken by *Atlanta Journal* photographer Bill Wilson in 1950. From left to right, players Ralph "Country" Brown, Henry Ertman, Ebba St. Claire, and Eddie Mathews were still getting dressed before the game when they were called to take promotional photographs for the news media. The paper elected not to publish these shots. These ballplayers led the Crackers to a first-place finish in 1950 with a 92-59 record. They hit a combined 89 home runs and were among the league's best power hitters. Mathews went on to a stellar career with the Milwaukee Braves before returning to play in Atlanta in 1966.

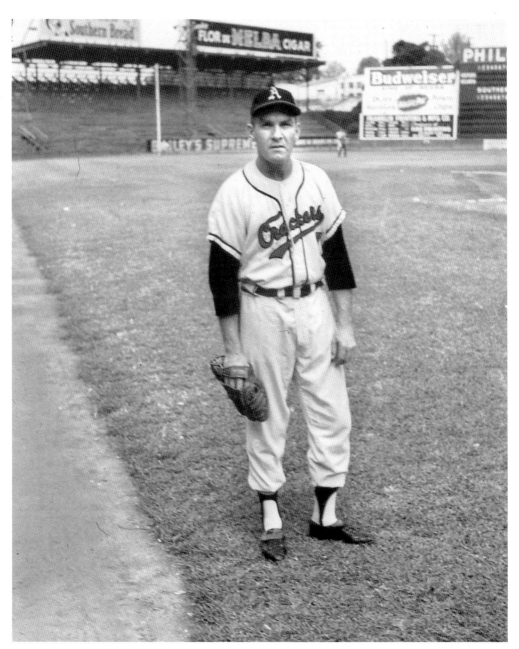

Bob Montag started his career at a torrid pace, blasting a franchise record 39 home runs and contributing 105 RBIs in his rookie season. Montag was among the most beloved players on the team during the 1950s. He hit for power and holds the franchise record for home runs at 113, but his propensity to strike out frequently and his poor play in the field consigned him to minor-league status. His career was punctuated by a 450-foot home run in 1954, during which the ball landed in a coal car on a train passing by on the tracks that lay beyond the right-field wall. Days later, Montag was visited by the train fireman, who presented him with the ball, which had traveled 518 miles on the train to Nashville, Tennessee, and back to Atlanta.

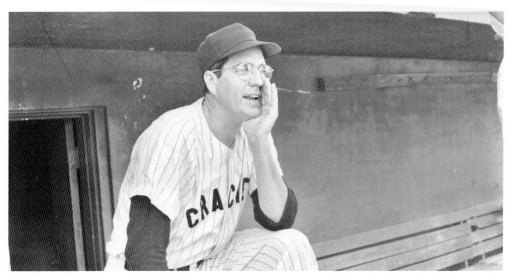

Manager Clyde King is pictured at the Crackers' spring-training facilities in Florida before the 1956 season. King managed the Crackers for just two years, winning the 1956 pennant before falling to the Houston Buffaloes in the Dixie Series. After several years in the minor leagues, King landed a job managing the San Francisco Giants in 1969 and later managed the Atlanta Braves. He briefly managed the New York Yankees in 1982 during an era in which owner George Steinbrenner replaced managers on an annual basis.

King began his career in baseball as a right-handed pitcher for the Brooklyn Dodgers at age 19 and played six years before being traded to the Cincinnati Reds, where he finished his playing days. In 1976, he joined the New York Yankees and served several roles, including scout, manager, general manager, and special advisor.

THE ATLANTA CRACKERS

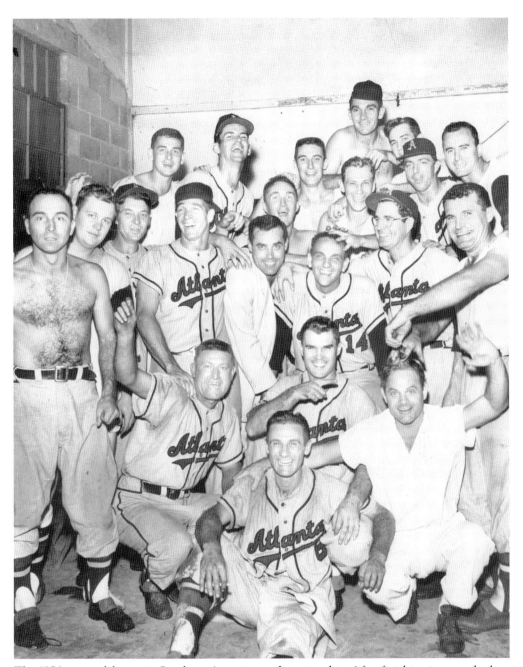

The 1956 team celebrates its Southern Association championship. After finishing in seventh place the year before, the squad returned most of their players to finish 89-65. The Crackers were not a statistically dominating team that year, but instead won with solid, consistent play up and down the lineup and on the mound. Manager Clyde King praised the team's chemistry throughout the season. "They stick together like a high school gang," he said.

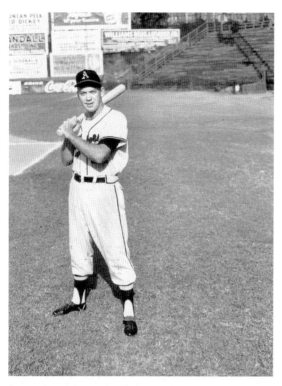

Clarence "Buck" Riddle joined the Crackers as a power-hitting first-baseman in 1956. In his first game with the club, he got five hits in as many at-bats, engendering the nickname "Five-for-five." In 1954, Riddle played for Jacksonville in the South Atlantic League, commonly known as the Sally League. He tied a league record with 28 home runs (more than Hank Aaron hit the previous year in Jacksonville). He was later called into the service and played for Fort McPherson's all-army baseball team in 1955.

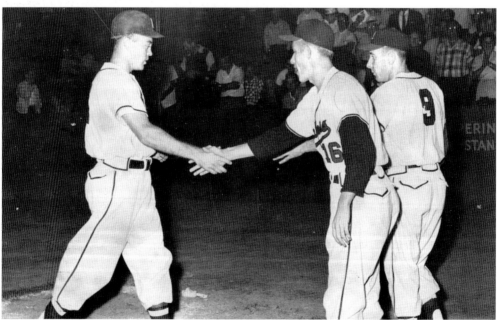

Buck Riddle is congratulated by teammates Jack O'Donnell and Dick Phillips after crossing home. Riddle left Wake Forest University as a freshman when the Milwaukee Braves organization offered him a $22,500 bonus. He was one of the Crackers' big guns but had difficulty breaking into the Braves lineup, which already had a magnificent first baseman in Joe Adcock.

Center fielder Jack Daniels, nicknamed "Sour Mash," was a fleet-footed power hitter who batted in the leadoff position and scalded Southern Association pitchers for 34 home runs during the Crackers' 1956 championship season. Daniels helped fill the base paths by drawing a league-leading 143 base-on balls, and his stellar play in the outfield produced a number of long-remembered defensive gems. His play earned him an all-star selection that year.

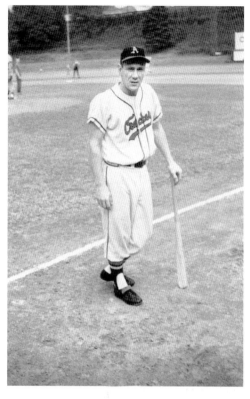

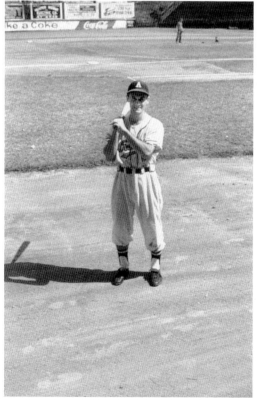

The 1956 Crackers did not feature players with great statistics, but if there were one player who could be singled out for his individual performance, it would be Frank DiPrima. The dandy little second baseman slumped at times but came through in the clutch countless times to lead his team into the Dixie Series. DiPrima finished the season with a .298 average, tops for the team.

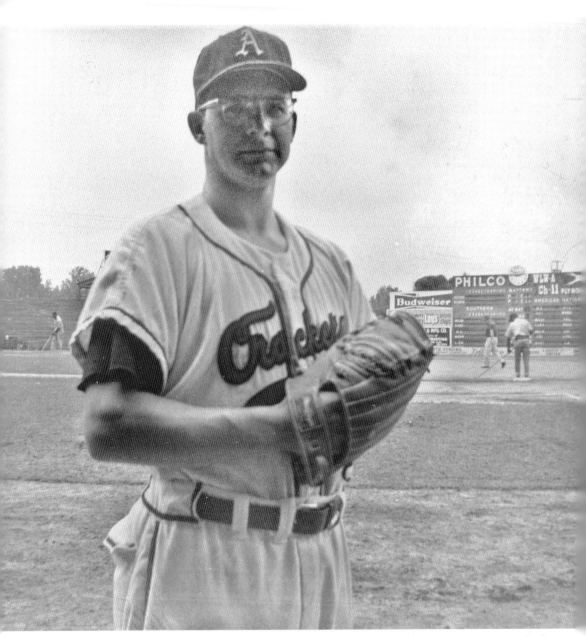

He had the looks and credentials of a college professor. Yale-educated Ken MacKenzie pitched for the Crackers in 1957 and 1958. He posted 14 victories during the 1957 season and was soon on his way to the big leagues. He debuted in 1960 for the Milwaukee Braves and the following year was dealt to the expansion New York Mets. MacKenzie was the only pitcher on the 1962 Mets to post a winning record and was among the few success stories on one of the most hapless teams in the history of baseball.

THE ATLANTA CRACKERS

Right-handed reliever Richard Grabowski warms up in the bullpen during a contest in 1956. Despite a short-lived professional career, Grabowski was a vital cog in the Crackers' championship season that year, posting 12 victories with an ERA of 3.61.

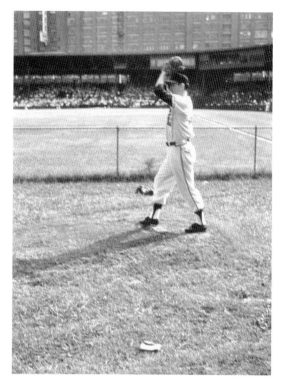

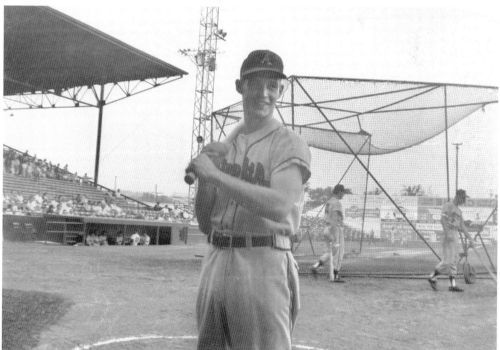

Catcher Sam Taylor led the Crackers in RBIs with 87 during their 1957 championship season and belted 12 homers.

Hank "The Prank" Morgan was a gregarious entertainer who broadcasted Atlanta Crackers games from 1954 to 1963. A sportscaster, disc jockey, and later a radio executive for WSB, he was one of the most popular radio personalities in Atlanta history. Like his predecessor, Ernie Harwell, Morgan employed a series of sound effects to bring the game to life. His voice was often heard on AM 790, WQXI, nicknamed "Quixie in Dixie" by its owners.

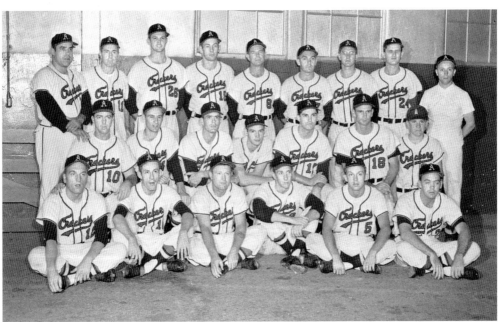

The 1957 Southern Association champion Atlanta Crackers are, from left to right, (first row) Robert Hartman, Jack O'Donnell, Sam Meeks, Richard Phillips, Ted Laguna, Buck Riddle; (second row) Billy Reynolds, Frank DiPrima, Paul Cave, Sammy Taylor, Don Nottebart, Everette Joyner, Orean Mann; (third row) Corky Valentine, Joe Morgan, Gerald Nelson, Charles King, Buddy Bates, unidentified, Ken MacKenzie, Ben Johnson, and trainer (unidentified).

Atlanta saw some of the game's best players at Ponce de Leon Park. A photographer catches an up-close action image of Babe Ruth during his last visit to Atlanta as a player in 1934. Young fans gathered early to watch Ruth blast pitches over the right-field fence during batting practice and to plead for autographs. The Yankees were in town for a two-day exhibition with the Crackers and won both games handily.

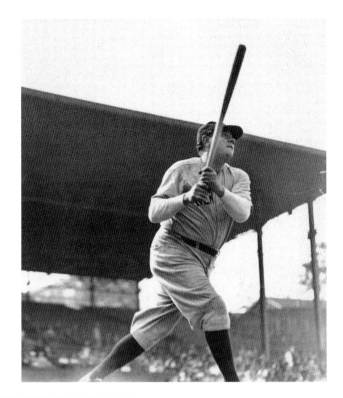

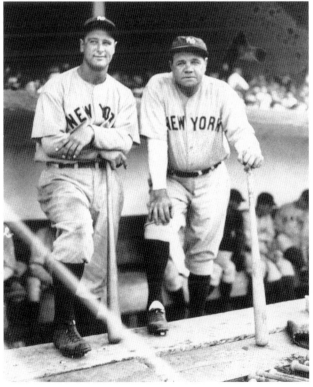

Babe Ruth and Lou Gehrig pose atop the dugout steps at Ponce de Leon Ball Park. These devastating power hitters punished major-league pitchers like no other duo in the history of the game. Gehrig unleashed an impressive display during the second game of the series with the Crackers, launching two home runs in the first inning, which netted the Yankees 11 runs.

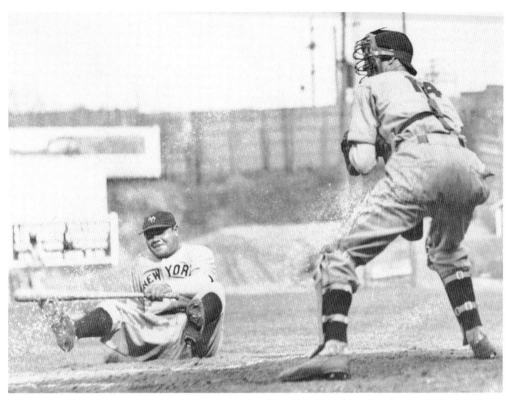

The Bambino hits the dust and laughs after a brushback pitch from an Atlanta hurler. Ruth was not only one of the most beloved figures in the history of the game, but he also revolutionized the sport. During his era, baseball changed from a pitcher-dominated sport to high-scoring hitting extravaganza. His 714 career home runs stood as a record for nearly four decades before it was broken by Atlanta Brave Hank Aaron.

Long after his playing days were over, Ruth and his wife, the former Claire Merritt Hodgson of Jefferson, Georgia, stopped in Atlanta on their way back to New York from a trip to Mexico in 1946. They were the guests of Jorge Pasquel, president of the Mexican League. Pasquel was attempting to bring major-league status to the Mexican League by offering inflated salaries to major-league stars to play south of the border.

THE ATLANTA CRACKERS

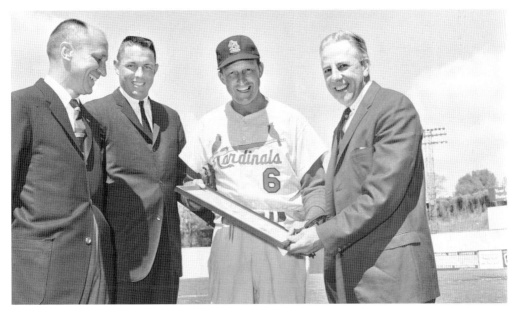

Stan Musial passed through Atlanta for a ceremony honoring him at Ponce de Leon Park around the time of his retirement from baseball. Musial was a seven-time batting champion and received the National League Most Valuable Player award three times. He is a member of the National Baseball Hall of Fame.

A fan captures Mickey Mantle at bat during an exhibition game in April 1952. The world-champion New York Yankees stopped in Atlanta for a three-game tilt with the Crackers after spring training ended. Mantle went two for nine in the series and cranked out a two-run home run in his first at bat.

Yankees lead-off shortstop Phil Rizzuto lays down a sacrifice bunt to advance runners. "The Scooter" was known as a skilled bunter and durable shortstop during the Bronx Bombers glory decades of the 1940s and 1950s.

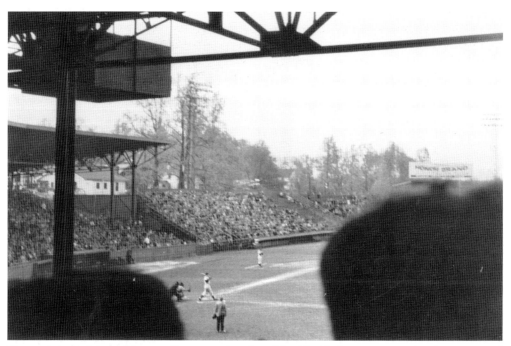

Slugger Johnny Mize takes a mighty cut at the plate. The North Georgia native hit for power and average during a prolific career with the St. Louis Cardinals, New York Giants, and finally the Yankees. The Yanks won this game 5-4 and swept the series against the Crackers.

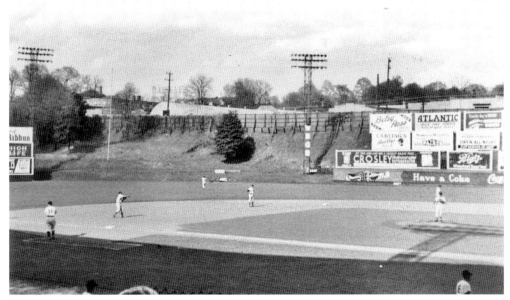

The same photographer was in attendance during a visit by the Detroit Tigers to Ponce de Leon Park the day after the series with the Yankees ended. Throughout his career, Earl Mann was able to attract the finest major-league clubs to come to Atlanta for exhibition games. The city was a convenient stop for clubs on the first leg of the trip north from spring training in Florida, with many flights coming in and out of Atlanta Municipal Airport. The top photograph features Tigers third baseman George Kell, a member of the National Baseball Hall of Fame. In the bottom photograph, Detroit shortstop Neil Berry gets under a pop fly to end the inning.

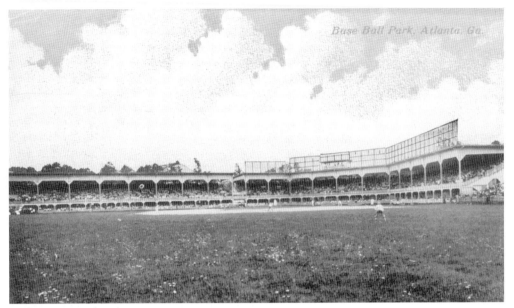

The Atlanta Crackers played their home games at various locations throughout their long history. The team led a nomadic existence until 1901, when the club began hosting games at Piedmont Park. They remained there until 1907, when a stadium was built on the northern outskirts of the city on Ponce de Leon Avenue.

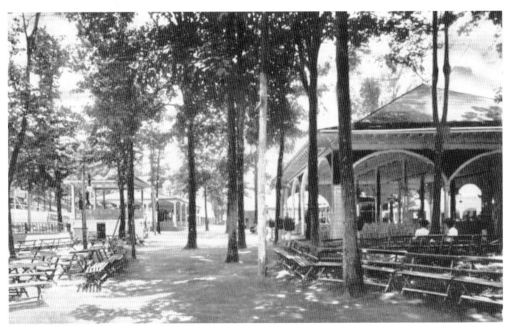

Directly across the street was an amusement park, named Ponce de Leon Park, which stood on the site of Ponce de Leon Springs. The area was named for the famed explorer shortly after the Civil War, when a railroad crew discovered pools of water that allegedly cured a camp-wide epidemic. Atlantans soon began making the two-mile trek to the area, which became a popular resort.

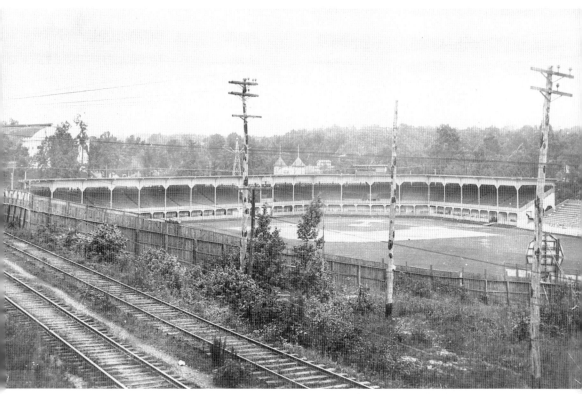

In 1906, the Georgia Railway and Electric Company bought an interest in the Atlanta Crackers and designed a ballpark. The stadium was built at a cost of $60,000 and opened on May 23, many weeks into the season. The railroad tracks adjacent to the outfield walls brought freight cars, whose operators sometimes slowed to a near halt to watch the action on the field. Youngsters often jumped on the tracks and watched games for free. In 1922, the power company sold the park to Rell Jackson Spiller. On September 9, 1923, a huge fire engulfed the wooden bleachers and destroyed the stadium, as well as the team's records, trophies, and uniforms. (Georgia Power Company Archives.)

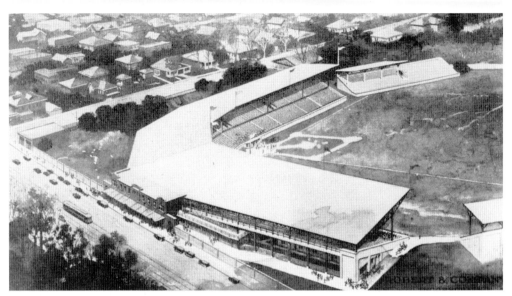

The new stadium opened the following May and was considered one of the top stadiums in the minor leagues. The seating capacity of the ballpark was raised to 14,000 to keep pace with Atlanta's rapid growth, and concrete stands with wooden seats replaced the old dilapidated wooden stands. The stadium was initially called Spiller Field, named after the former owner of the Crackers, but was renamed Ponce de Leon Park in 1932.

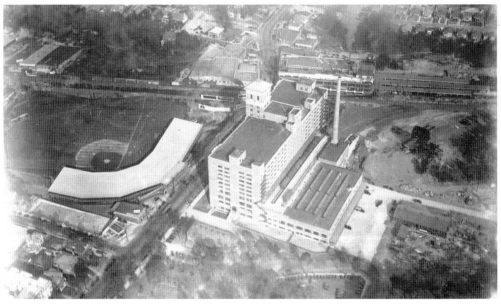

The amusement park across the street from Spiller Field was torn down in 1926 and replaced with an enormous retail and distribution center operated by Sears, Roebuck, and Company. The retail giant was a popular destination for visitors, who often included it in their itinerary when attending Crackers games. This aerial view taken in the 1930s shows that Ponce de Leon Park was also used for football games.

THE ATLANTA CRACKERS

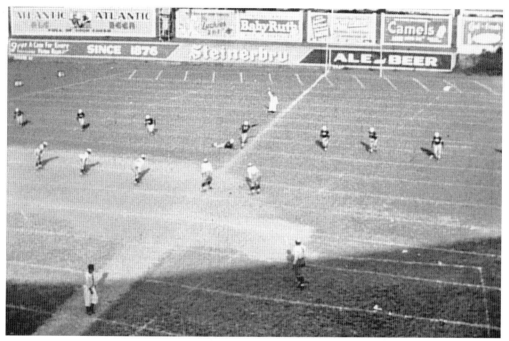

Teams from Atlanta University, Morehouse College, and Morris Brown sometimes played their fall football games at Ponce de Leon Park. This photograph was taken in the late 1930s and shows a game between Morehouse College and an unidentified opponent. In addition to football games, the facility was used for mass meetings and religious revivals.

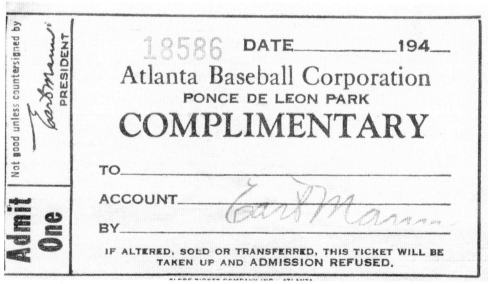

This complimentary pass to the ballpark is signed by Earl Mann. The Atlanta Baseball Corporation was the name Mann used to incorporate the Atlanta Crackers franchise. The Coca-Cola Company purchased the team as a civic gesture to keep professional baseball alive in the city during the Great Depression. Mann purchased the club outright in 1949.

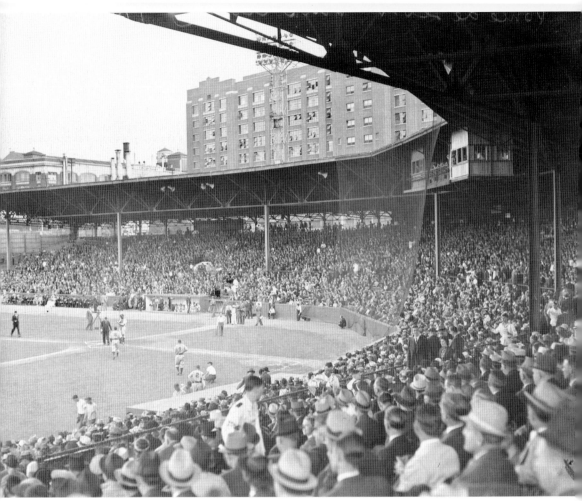

The 1940s marked a prosperous era for the Atlanta Crackers and for minor-league baseball in general. The team won four pennants in six years, but their popularity was independent of their success on the field. Attendance at Poncey rose throughout the decade, peaking at 404,584 in 1947 despite the team finishing 20 games out of first place. The increased turnout was stimulated in part by early Sunday afternoon doubleheaders, which sometimes conflicted with church services.

THE ATLANTA CRACKERS

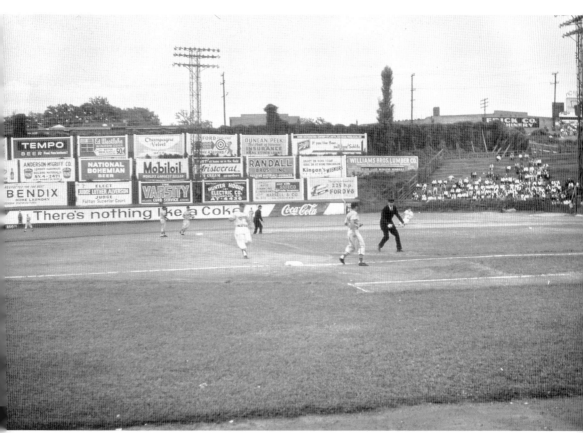

Crackers fans came to the games to see baseball and also to gamble. Gambling had to be conducted in the outfield bleachers because of a Georgia law allowing gambling if it did not take place under a roof. Fans would place bets with bookies on whether a batter would hit a fly ball and if an outfielder or infielder would catch it. Sometimes, when an opposing player would drop a fly ball, it would produce dramatically different reactions from the fans in bleachers who booed and fans in the grandstands who cheered.

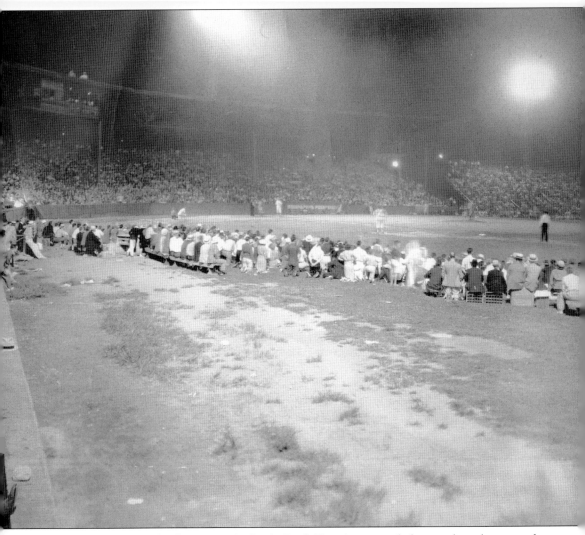

In 1937, the season finale against the Little Rock Travelers preceded a match up between the Crackers and a team of aging Southern Association stars. After the Travelers beat the Crackers 7-4, the old-timers, led by one of the game's greatest pitchers, Denton (Cy) Young, "defeated" the home team. No score was kept in the game, which featured players in their 70s. Young himself

THE ATLANTA CRACKERS

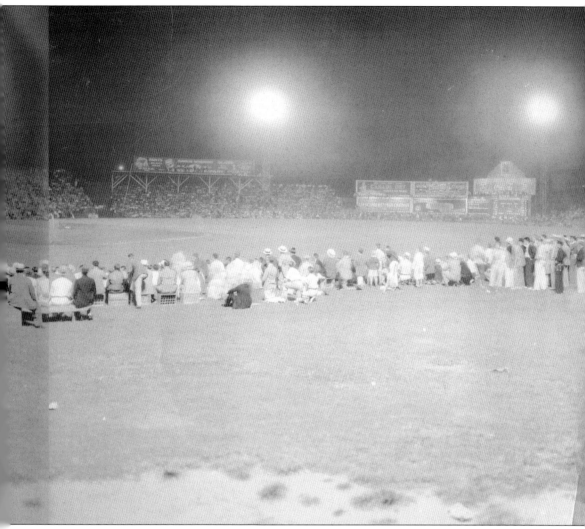

was 70, and although he had no official connection to the Atlanta franchise, he was a strong ambassador for the game during his retirement. Young pitched one inning in a game that also featured former greats like ex-major-leaguers Doc Johnson and Bob Higgins, who was once Cy Young's catcher with the Cleveland Indians. The game drew more than 12,000 fans.

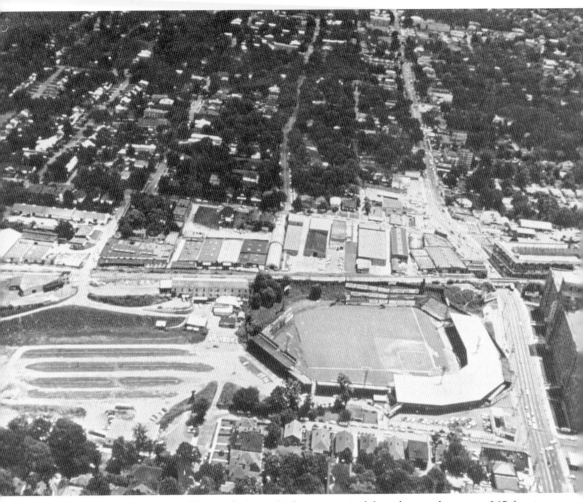

The original dimensions of Ponce de Leon Park as measured from home plate were 365 feet in left field, 321 feet in right field, and a very deep 462 feet in center field. In later years, a cyclone fence was installed running from the left-field foul line to the edge of center field, reducing the dimensions to 330 feet in left field and 410 in center field.

THE ATLANTA CRACKERS

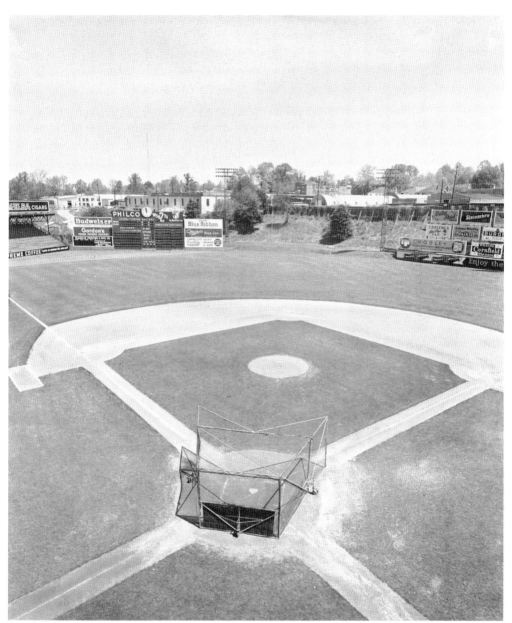

One of the most distinguishing characteristics of Ponce de Leon Park was a giant magnolia tree in deep center field, 462 feet away from home plate. In place of a fence in center field was a steep grassy embankment, which was considered part of the field. Balls hit there were considered in play. If a batsman hit a pitch into the tree it was ruled a home run, making Ponce de Leon the only park in baseball history to have ground rules allowing a tree in the outfield. Babe Ruth and Eddie Mathews have been credited as being the only players to hit balls into the tree in center field. The park was razed in 1966; however, the magnolia tree still stands today behind a parking lot servicing a number of retail stores that populate the area.

BASEBALL IN ATLANTA

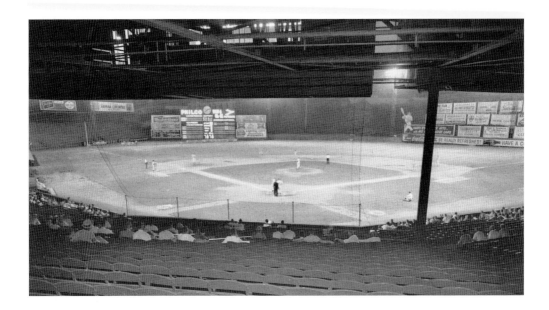

The Crackers, and minor-league baseball in general, experienced a steady erosion of attendance that began in 1950 and continued throughout the decade. The decline was precipitated by economic expansion, more affluent tastes, and technological innovation. Middle-class parents bypassed the surly atmosphere of minor-league stadiums in favor of local Little League parks in the suburbs where their sons and daughters played. Golf games, tennis matches, and outings at the lake attracted the attention of the city's newcomers. Television and air-conditioning bolstered the comforts of home. This of course had a dramatic effect on the team's finances. Losing money with a last-place ball club, Earl Mann turned the franchise over to the Southern Association, whereupon it was purchased by Los Angeles Dodgers owner Walter O'Mally. It was the end to an astounding era of success.

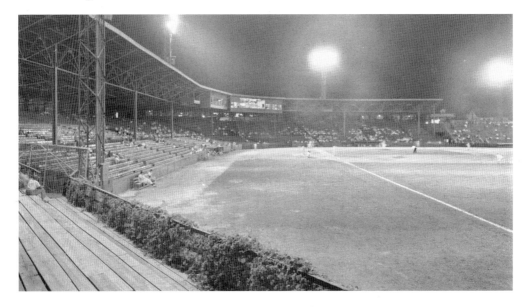

THE ATLANTA CRACKERS

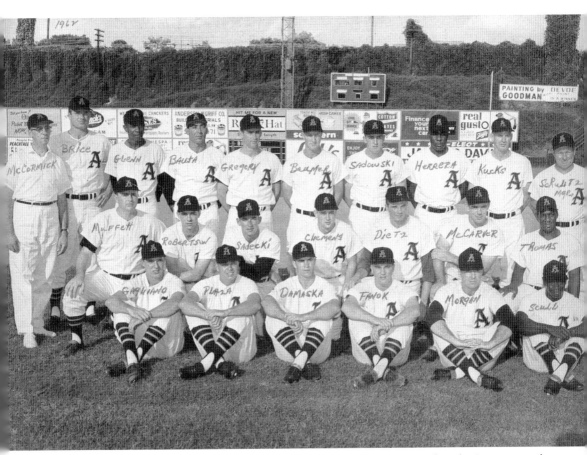

After the demise of the Southern Association in 1961, the Crackers moved to the International League and won the 1962 Junior World Series. By this time, the Crackers were the AAA affiliate of the St. Louis Cardinals, who were grooming a young catcher named Tim McCarver (second row, second from right). The manager that year was Joe Schultz, who later went on to manage in the big leagues and is perhaps best known through a book titled *Ball Four*, an exposé written by pitcher Jim Bouton chronicling his season with the expansion Seattle Pilots in 1969. The 1962 squad was the first integrated team to take the field for a regular-season game at Ponce de Leon Park. The Crackers were the first and only Southern Association team to integrate. In 1954, catcher Nat Peeples signed from the Negro leagues but was released before ever taking the field in a regular-season game in Atlanta.

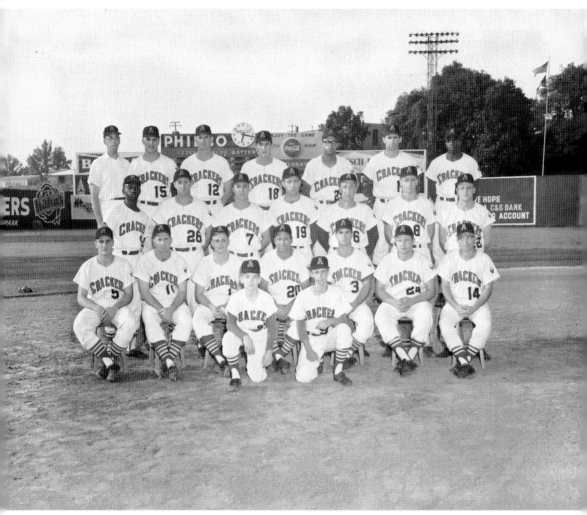

The 1963 edition of the Crackers finished 85-68, well enough for second place, one game behind the Indianapolis Indians in the Southern Division of the International League. The league expanded to 10 clubs in 1963 and prompted the divisional split. Finishing second in the division qualified the Crackers to play in a seven-game series against the Toronto Maple Leafs, who had finished second in the Northern Division. After they swept Toronto in four games to claim the Governor's Trophy, the Crackers' manager angrily challenged the Indians to a one-game playoff after observers accused Atlanta of wilting under pressure during the divisional race.

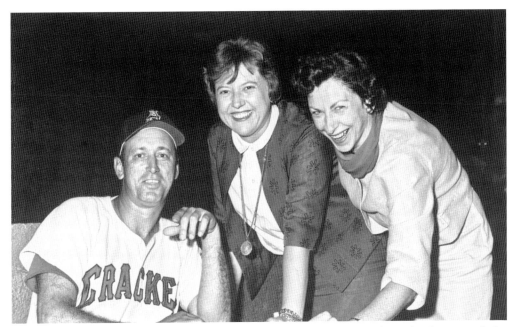

The 1963 squad was managed by Harry Walker, a famed player and coach who compiled a .296 batting average with four major-league teams and managed the Pittsburgh Pirates and Houston Astros. Included in this picture with Walker are Fay Brinan and Ann Berg of Rich's Department Store.

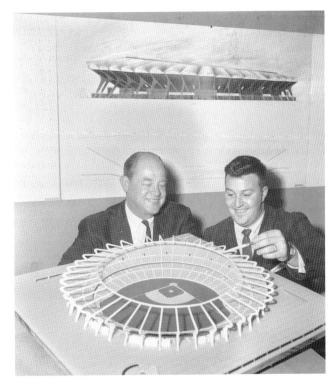

Former Atlanta Crackers owner Earl Mann (left) and an unidentified man scrutinize a model of Atlanta Stadium. Mann remained involved in baseball even after he relinquished his role with the Crackers. He became an active voice in the city's effort to attract a major-league franchise, going so far as to meet with owners of prospective franchises and serving on the Atlanta Stadium Authority.

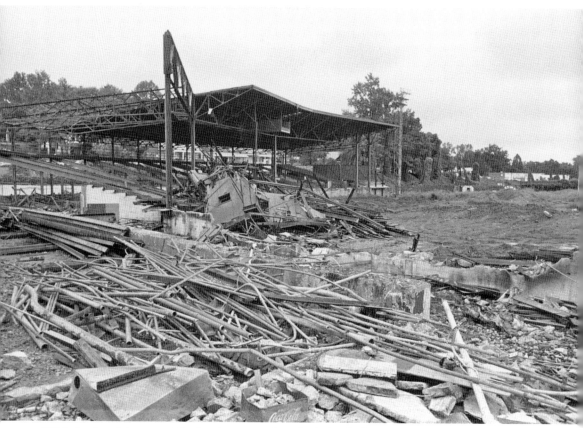

With the franchise vanquished and a new stadium built for the home team, there was little reason for Ponce de Leon Park to remain. In September 1965, Earl Mann decided to sell the 10-acre site, which occasionally hosted prizefights and semi-professional football games after the Crackers were disbanded. The property was sold at auction for $1.25 million and demolished the year after. There were some who lamented the destruction of the old stadium, but the excitement of a major-league franchise coming to town dulled the sentiments of most Atlantans. The Crackers played their last season in newly built Atlanta Stadium.

THE ATLANTA BRAVES

Pictured is the full itinerary for opening day, April 12, 1966. An estimated 50,000 fans came to witness Atlanta make the switch from bush league to big league at Atlanta Stadium. The Braves lost a 3-2 thriller to the Pittsburgh Pirates off a Willie Stargell home run in the 13th inning.

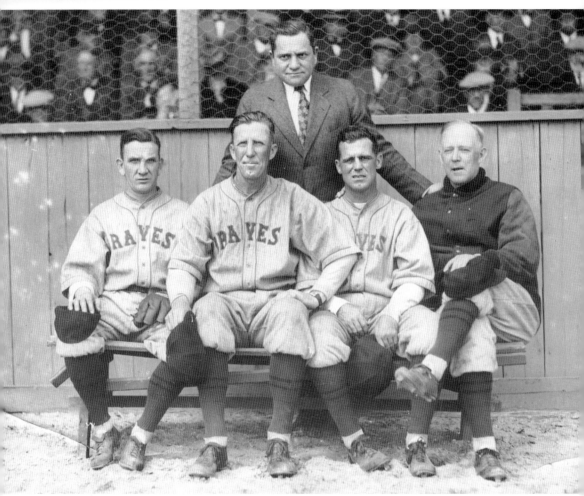

The history of the National League Braves franchise dates back to 1876 with the Boston Red Stockings. In subsequent years, the team was known as the Beaneaters, the Doves, the Pilgrims, and finally, in 1912, the Braves. The Braves were World Series champions in 1914 and appeared again in 1948. Pictured is team owner Judge Emil Fuchs, with, from left to right, players Walter Maranville, Hank Gowdy, George Sisler, and Johnny Evers. Fuchs owned the club from 1923 to 1935, a particularly dismal era in its history. In a desperate move to save money, he appointed himself manager in 1929, and the club finished dead last. Fuchs was the last major-league baseball manager with no playing experience on any level until 1977, when Atlanta Braves owner Ted Turner managed the team for one game.

Leading the Boston Braves in their 1948 pennant charge was pitcher Warren Spahn. Spahn and Johnny Sain, also a pitcher, were immortalized in a famous phrase derived from a poem by Boston reporter Gerald Hern. "First we'll use Spahn, then we'll use Sain, then an off day, followed by rain; Back will come Spahn, followed by Sain, and followed we hope by two days of rain." In 2003, the Atlanta Braves unveiled a statue of Spahn outside Turner Field that captures the left-hander's famous high-leg kick.

Former Atlanta Crackers manager Whitlow Wyatt was a pitching coach for the Milwaukee Braves, and later the Atlanta Braves. In his day, he was one of the best pitchers in the National League, compiling a record of 78 wins and 39 losses between 1939 and 1943. Wyatt is a native of Kensington, Georgia, and is a member of the Georgia Sports Hall of Fame.

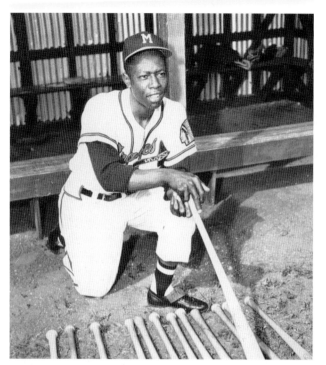

Henry Louis "Hank" Aaron began his professional baseball career in the Negro American League as an infielder for the Indianapolis Clowns. Aaron was a fantastic ballplayer, despite having never received any formal coaching as a youngster. He employed an unorthodox, cross-handed batting style, and was largely ignored by professional scouts. In 1952, he led his team to victory in the Negro League World Series, and his contract was picked up by the Boston Braves. He was the last Negro-league player to advance to the major leagues.

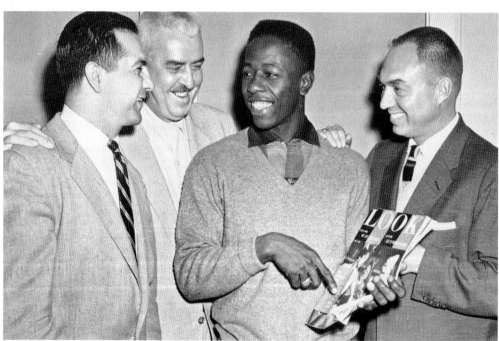

Aaron broke into the starting lineup for the Braves in 1954 after an injury to outfielder Bobby Thompson. He finished the season batting .314 with 27 home runs and 106 RBIs. In 1956, he won his first batting title and was named National League Player of the Year by the *Sporting News*. Known already as "Hammerin Hank" at age 22, he was featured in *Look* magazine.

Chuck Tanner made a huge splash in his 1955 big-league debut with the Milwaukee Braves, hitting a home run on the first pitch he saw. Tanner's career in the Braves organization developed in Atlanta, where he was a star outfielder for the Crackers from 1951 to 1954. After his playing days, he began a long and successful career as a manager with four major-league teams, most notably the Pittsburgh Pirates, where he won a World Series. He managed the Atlanta Braves from 1986 to 1988.

With his tall and lanky frame, Ernie Johnson fit the mold of a big-league pitcher. As a relief pitcher with the Braves from 1950 to 1958, Johnson compiled an outstanding ERA of 3.27. He pitched well in a World Series game against the New York Yankees but lost the decision after giving up a solo home run. Johnson became an announcer and called games on radio and television for the Atlanta Braves from 1966 until his retirement in 1999.

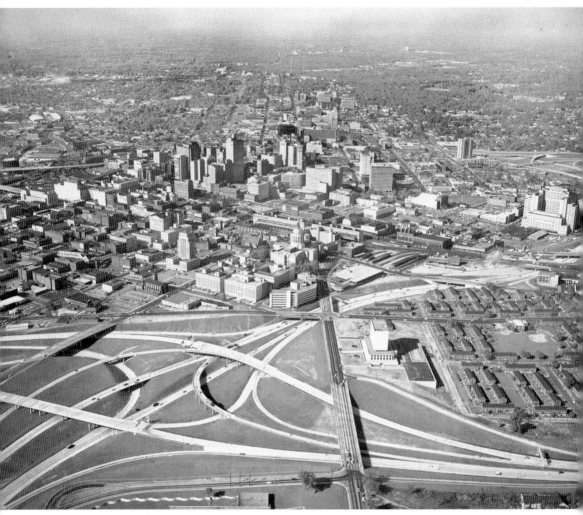

By the 1960s, Atlanta was poised to become a great city. Perhaps best known as the location for *Gone with the Wind*, Coca-Cola, and Bobby Jones, Atlanta was a regional leader in transportation, industry, and education. And while some Southern cities made national headlines for racial turmoil and violence, Atlanta desegregated its schools, buses, and golf courses with comparatively less strife and upheaval and therefore gained a reputation for moderation. The Atlanta Chamber of Commerce lured new businesses, which stimulated the construction of skyscrapers and office buildings. City leaders built on this foundation by aggressively promoting for enhanced expressways, rapid transit, and stadium facilities to attract professional sports teams to Atlanta.

THE ATLANTA BRAVES

Furman Bisher, sports editor of the *Atlanta Journal*, and Charles O. Finley, owner of the Kansas City Athletics, helped jump-start Atlanta's effort to build a major-league facility. Bisher (standing, with *Journal* editor Ed Danforth) brought Finley to Atlanta in April 1963 to show him potential locations for a stadium to accommodate his struggling franchise.

One of their first stops was Lakewood Park, which included a fairgrounds and a dilapidated one-mile dirt track that had once featured stock car races and daredevil drivers. In 1961, the Atlanta Chamber of Commerce formally proposed to build a domed stadium on the site and even built a small-scale model for study and display. Today the site is primarily used for outdoors concerts and a flea market.

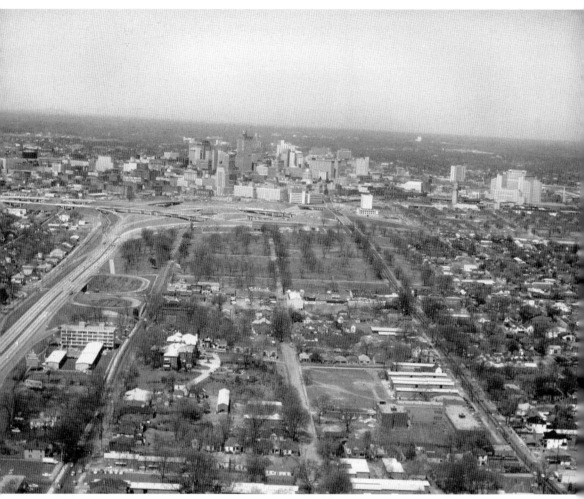

The next day, Atlanta mayor Ivan Allen Jr. drove Bisher and Finley to the Washington-Rawson area adjacent to the Summerhill neighborhood. Located less than a mile from downtown, it seemed like an ideal location. Summerhill was developed after the Civil War as Atlanta's first African American real-estate development and evolved into a mixed community that included Jews and Greeks. Washington-Rawson was once an upscale neighborhood filled with ornate mansions. In the 1950s, the area began to decline, and Washington-Rawson was targeted for urban renewal. Part of the land was used to build highway interchanges and overpasses, while the rest remained undeveloped. Finley loved the location and told Allen, "You build a stadium here and I guarantee you Atlanta will get a Major League franchise." Allen boasted of "the greatest site for a sports stadium in America."

Ivan Allen Jr. began promoting the idea of bringing a major-league team to Atlanta as president of the chamber of commerce in 1960. Allen had now attracted the genuine interest of a team owner; the next step was to "build a stadium on ground we didn't own, with money we didn't have, for a team we didn't sign." He quickly turned to a man he could count on to finance the deal, Mills B. Lane (bottom image), chairman of the Citizens and Southern National Bank. Known for his unconventional manner and for his collection of antique automobiles, Lane was also a shrewd investor. After visiting the site with Allen, Lane agreed and proceeded to spend hundreds of thousands of dollars on site surveys and architectural and engineering designs.

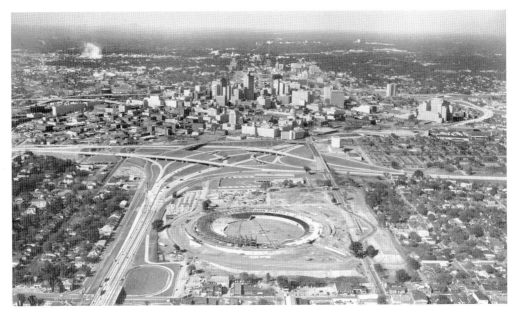

Finley could not gain permission from his fellow owners to move to Atlanta, but almost immediately, Allen and his contingent of baseball supporters began talks with the owners of the Milwaukee Braves. Construction on the stadium began in April 1964, shortly after a deal was signed, but legal matters prevented the team from moving in time for the 1965 season. Atlantans would have to wait until 1966 for their new sports franchise.

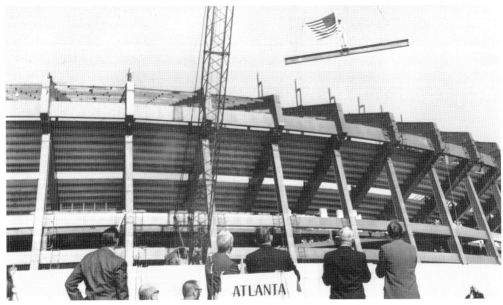

The final piece of steel is hoisted to the top of Atlanta Stadium, along with an American flag and a mannequin dressed in an Atlanta Braves uniform during a "topping out" ceremony in January 1965 to commemorate progress on the ballpark. Architect George Heery led the effort to complete the job in less than one year, an astonishingly rapid pace.

THE ATLANTA BRAVES

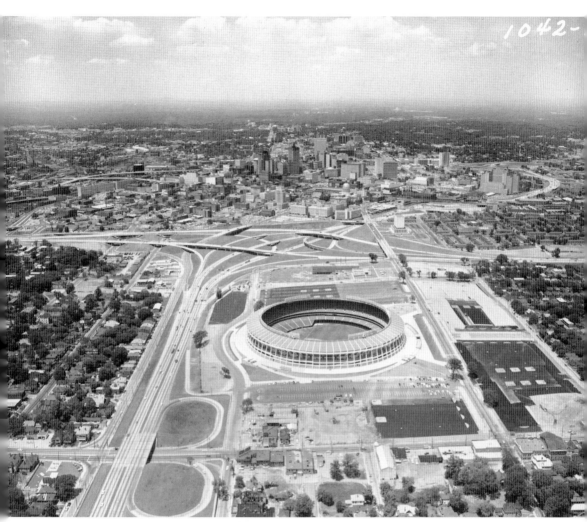

Atlanta Stadium was built in time for an exhibition game between the Milwaukee Braves and the Detroit Tigers on April 9, 1965. The stadium would play home to the Atlanta Crackers in what would be their final year of existence. Noting its proximity to downtown and interstate expressways and touting the abundance of available parking, the *Atlanta Journal and Constitution* magazine billed the stadium as a model of convenience for fan access and attendance. In later decades, as the city's population diffused into the suburbs and the logistics of getting to the stadium became more complicated, critics and fans complained about its isolated location.

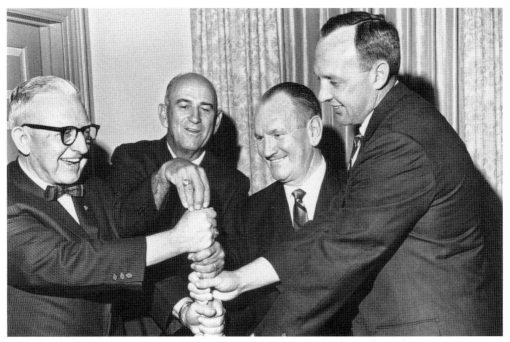

From left to right, Georgia baseball legends Tubby Walton and Luke Appling join Milwaukee Braves executives Eddie Glennon and Ernie Johnson to celebrate the arrival of the team to Atlanta.

A few weeks after the end of the 1965 regular season, the newly minted Atlanta Braves players, coaches, and owners launched their drive for tickets sales for the 1966 National League season. From left to right are player Eddie Mathews, President and General Manager John McHale, executive Eddie Glennon, and former Braves and Crackers coach Whitlow Wyatt.

THE ATLANTA BRAVES

Hank Aaron prepares an autograph for young admirers as Eddie Mathews (left) and pitcher Tony Cloninger (right) look on. The Braves players visited several hospitals in Atlanta as part of a promotional goodwill caravan in the fall of 1965.

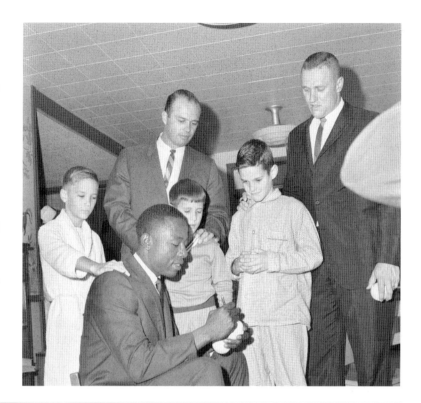

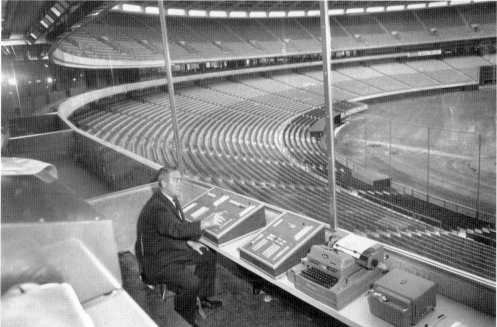

This photograph looks inside the booth housing the scoreboard operator and the surrounding press boxes. Atlanta Stadium cost $18 million to build. With 51,294 seats, it was the seventh-largest stadium in the major leagues.

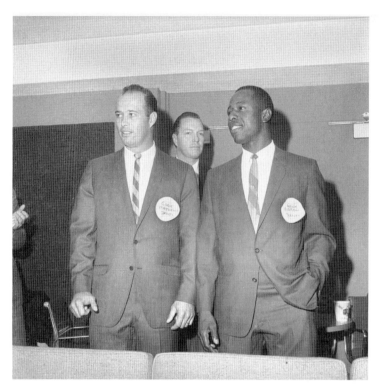

Dugout and club-level tickets for the 1966 season cost $375, while field-level tickets cost $250. Ticket sales were driven by the star power of the Braves, and two of the biggest names on the team were third baseman Eddie Mathews and outfielder Hank Aaron. By 1966, the two Hall of Fame players had hit a combined total of 875 home runs. That number had reached 1,267 when their careers ended.

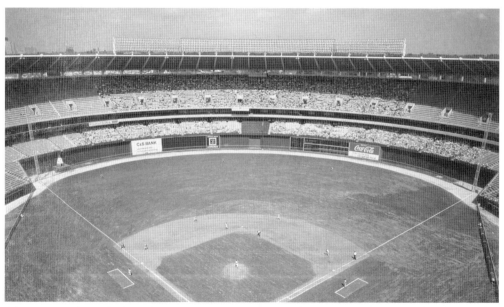

Like many stadiums built in the 1960s, Atlanta Stadium was a symmetrical ballpark. The reported dimensions upon completion were 325 feet from home plate, 385 feet in the power alleys, and 404 feet in center field. The trend of evenly proportioned ballparks became widespread when developers in cities like Atlanta built in open sites. Without the constraints of city streets, architects usually built round structures with a symmetrical field layout.

In addition to its use as the home of the Braves, Atlanta Stadium (renamed Atlanta–Fulton County Stadium in 1976) also accommodated home games for the Atlanta Falcons, who also began play in 1966. Facility managers envisioned the stadium hosting college football games, including perhaps the Georgia-Florida football game held annually in Jacksonville, Florida (but that dream went unrealized). Atlanta Stadium also accommodated concerts by the Beatles and revivals sponsored by Billy Graham.

Fan attendance during the Braves' inaugural season in Atlanta surpassed the 1.5 million mark, slightly above the league average. Attendance would gradually slip in subsequent years, as the excitement of a new team faded. The franchise would not better the inaugural-year audience until 1982.

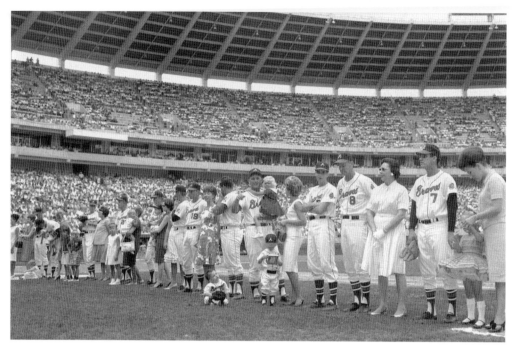

Members of the Atlanta Braves and their wives and children are introduced to the fans before a game in August 1966.

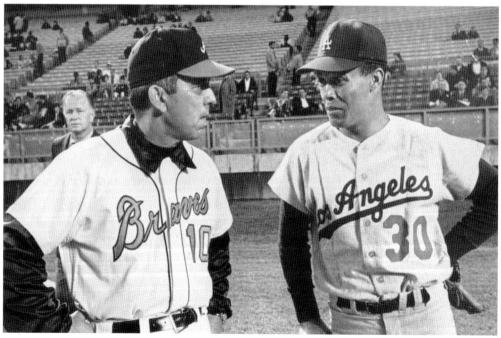

Braves manager Bobby Bragan, seen here with Maury Wills of the Los Angeles Dodgers, was hired for the job in 1963. His tenure with the club was short-lived, but his teams usually finished over .500. In 1966, with the team several games below the break-even point, he was let go.

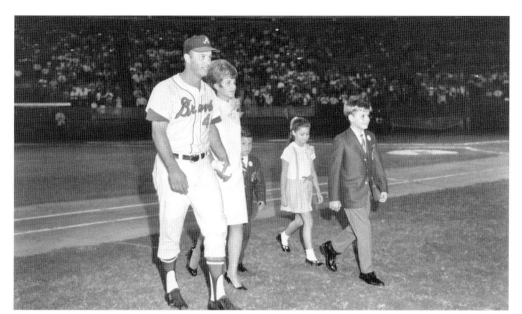

Braves captain Eddie Mathews escorts his wife Virjean and their three children to the infield on "Eddie Mathews Night" at Atlanta Stadium. Mathews was a legend among Atlanta baseball fans from when he was an 18-year-old whiz kid for the Crackers until his final days with the Braves. Hall-of-Famer Ty Cobb said of Mathews: "I've only known three or four perfect swings in my time. This lad has one of them."

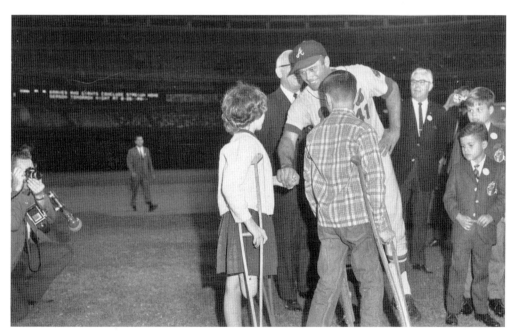

"Eddie Mathews Night" raised over $10,000 for the Scottish Rite Hospital for Crippled Children. Accepting Mathews's gifts are Donna Swinford and Glenn McRoberts, who had been patients at the hospital.

The celebration fell on Mathew's 12th wedding anniversary, at the end of the 1966 season. Mathews would be traded to the Houston Astros, where he would finish his career a year later. Among the gifts he received in appreciation were a boat, a new car, and bikes for his children, including his eldest son, Edwin.

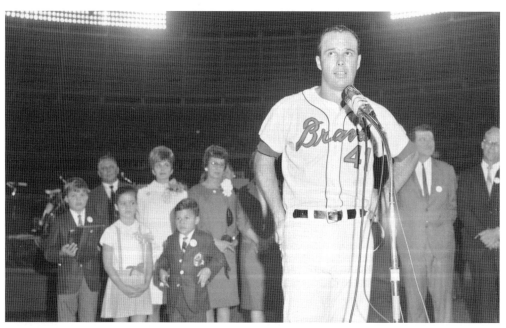

Emotional and nervous, Eddie Mathews prepared a speech but was overcome and instead talked about his father, who had thrown him pitch after pitch and helped him develop his perfect swing. Mathews played in more than 2,300 games, hit 512 career home runs, and was a nine-time all-star.

THE ATLANTA BRAVES

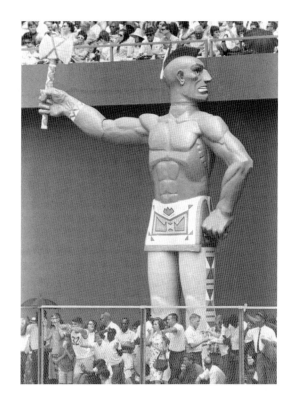

For the first few years in Atlanta, one of the Braves' mascots was Big Victor, a 22-foot-tall statue of a Native American perched beyond the right-field fence. The installation of Big Victor was a prime example of a promotional idea gone awry. Every time a member of the Braves would hit a home run, Victor was supposed to wave the tomahawk in his right hand, tilt his head, and roll his eyes. Many times, however, the Styrofoam statue would wave and blink without any prompting from its operator. Due to mechanical problems, the mascot was removed in 1969, never to return.

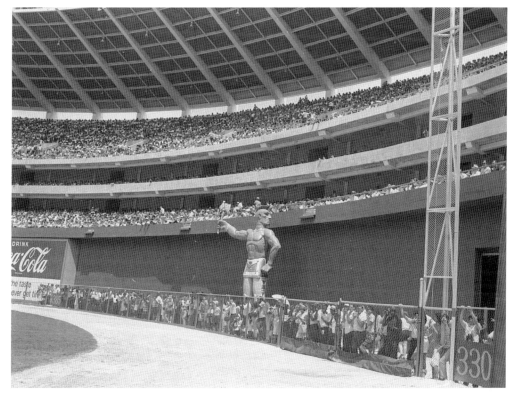

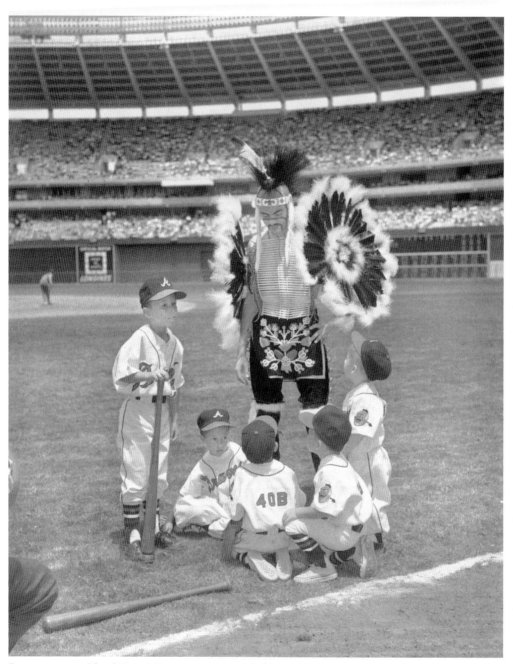

Braves mascot Chief Noc-A-Homa entertains children before a game in 1966. The organization hired two individuals for the mascot job, neither of whom were Native American, until they hired Levi Walker Jr. in 1969; he filled the position until 1986. A teepee was placed behind the left-field fence, and Chief Noc-A-Homa would sit in it and perform spirited dances after Braves home runs. In 1982, the Braves removed the teepee to make room for more seats.

THE ATLANTA BRAVES

The Atlanta Braves conducted spring training in West Palm Beach, Florida, until 1997, before migrating to Cracker Jack Stadium in Disney's Wide World of Sports Complex in Orlando. When the franchise played in Boston, spring training occurred in towns throughout Georgia, including Columbus, Macon, Athens, Thomasville, and Augusta.

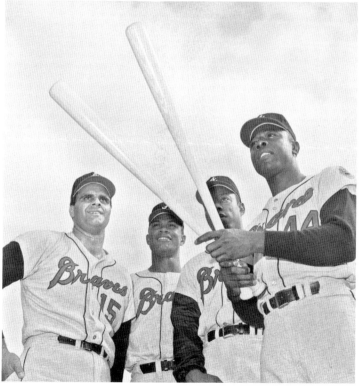

Although they held a high profile during their playing days, the Braves lineup in the late 1960s also included players who later became prominent in the game, including, from left to right, catcher Joe Torre, center fielder Felipe Alou, outfielder Mack Jones, and left fielder Hank Aaron. Both Torre and Alou were two-time all-stars for the Atlanta Braves and also managed World Series champions after their playing days were over.

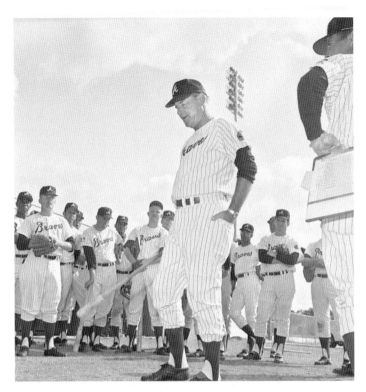

Braves manager Charles Luman Harris opens spring training in 1969 with a speech to the veterans and rookies. Harris was a longtime manager and coach in the major leagues, managing for the Houston Astros, the Baltimore Orioles, and finally the Atlanta Braves. He was a pitcher in his playing days and debuted professionally with the Atlanta Crackers in 1937. He led the Atlanta Braves to their only playoff appearance in their first 17 years of existence.

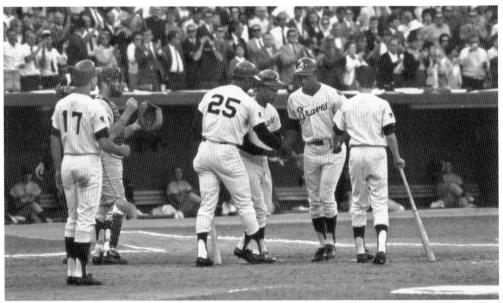

In 1969, both the National League and American League took a step away from tradition and opened divisional play, which necessitated a playoff to determine the pennant winner. The Braves were Western Division champions and played the New York Mets for the right to play in the World Series. Hank Aaron belted three home runs in the series but it was not enough, as the Braves lost three games to zero.

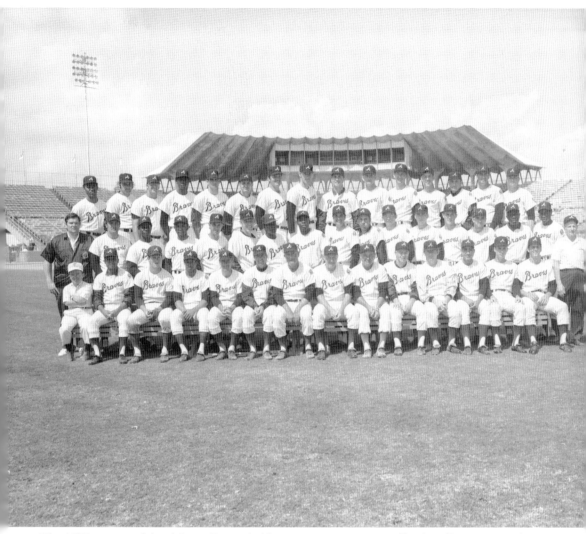

The 1970 version of the Atlanta Braves held great promise coming off a playoff appearance, but injuries combined with a lack of depth doomed their regular season. From left to right are (first row) traveling secretary Don Davidson, Gil Garrido, Bob Didier, Sonny Jackson, coach Billy Goodman, coach Jim Busby, manager Luman Harris, coach Ken Silvestri, coach Harry Dorish, Tom House, Pat Jarvis, Felix Millan, Mike McCammon, and Mike McQueen; (second row) trainer Dave Pursley, Mike Lum, Ralph Garr, Tony Gonzalez, Hoyt Wilhelm, Bob Priddy, Hal King, Tommie Aaron, Bob Aspromonte, Clete Boyer, Darrell Evans, Stan Bell, Garry Hill, Rick Kester, Hank Aaron, Dusty Baker, and equipment manager Mark Gladulich; (third row) Oscar Brown, Milt Pappas, Jim Breazeale, Bob Michell, Marian Murphy, Larry Jaster, Jim Nash, Ron Reed, Gary Niebauer, Ron Schueler, Cecil Upshaw, George Stone, Phil Niekro, Bob Tillman, and Jimmy Britton.

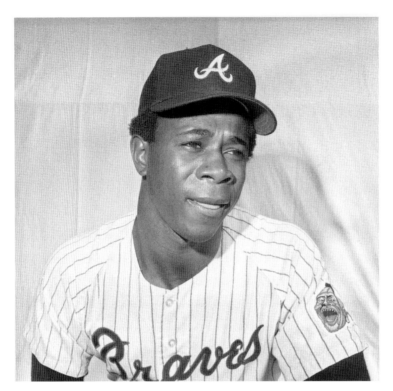

Speedster Ralph Garr was an outfielder for the Braves from 1968 to 1975. He led the National League in hitting with a .353 average in 1974. Known as an outstanding hitter but less adept in the field, he is the Atlanta Braves' all-time leader in triples with 40. After his playing days were over, he worked as a scout and coach in the Braves organization.

Dusty Baker was another future big-league manager who broke into the major leagues with the Atlanta Braves. Like Ralph Garr, Baker's rookie season was 1968, but he did not gain a foothold with the team until 1971.

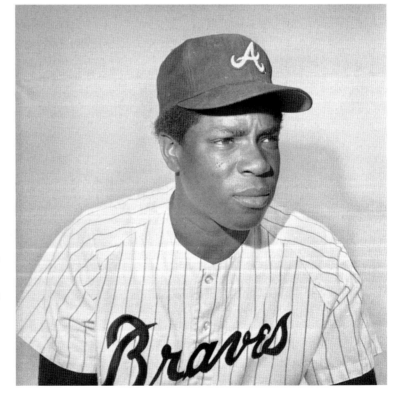

THE ATLANTA BRAVES

Outfielder Tony Gonzalez was the spark the Braves needed during their 1969 pennant run. A slick fielder and consistent hitter, Gonzalez, along with Rico Carty, Hank Aaron, and Orlando Cepeda, constituted a formidable lineup. Already a nine-year veteran when he joined the Braves, Gonzalez was traded the following year to make room for younger talent.

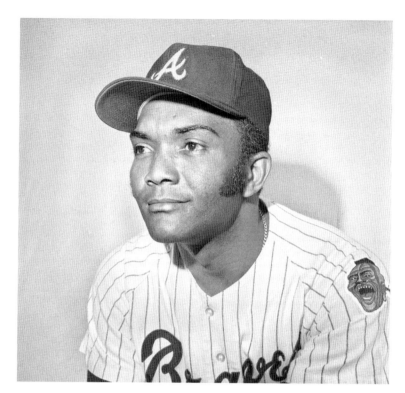

Hank Aaron crosses home plate after taking an American League pitcher deep during the 1972 All-Star Game at Atlanta Stadium. It was the first and only time the annual contest was played at Atlanta Stadium. Atlanta was the host site in 2000, when the game was played at Turner Field. The National League won the game 4-3 in 10 innings.

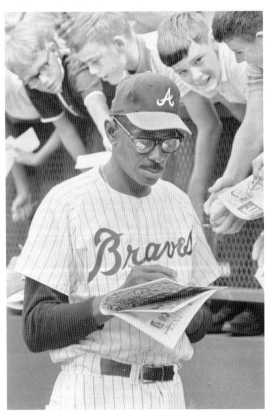

Two baseball legends, Hank Aaron (top) and Leroy "Satchell" Paige (bottom), sign autographs for young fans. By 1969, Aaron had long been a bona fide star. He had surpassed the 500–home run mark and was consistently putting up great numbers. Aaron also spoke frequently about the need for racial equality in baseball. Although Aaron was much younger, he and Paige had similar backgrounds. Both grew up poor in Mobile, Alabama, and began their professional careers in the Negro leagues. Both faced racial discrimination throughout most of their careers. One of the greatest pitchers of all time, Paige did not get the opportunity to play in the major leagues until 1948, when he was well past 40. In 1969, the owner of the Braves, William Bartholomay, signed Paige to a contract as a pitching coach. He served long enough to qualify for a major-league pension.

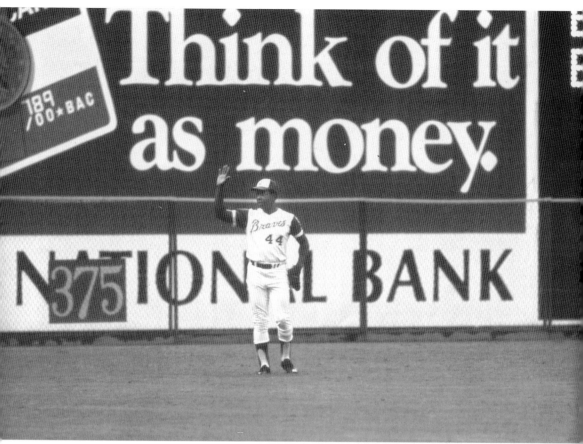

Hank Aaron receives a warm ovation from the home crowd in Atlanta during the ninth inning of the last game of the 1973 season. Aaron, who was slowly closing in on Babe Ruth's record of 714 home runs, would later describe the outpouring of fan support as "the biggest moment I've had in baseball." The day before, he hit his 713th home run, setting up a dramatic conclusion to a pressure-packed year, but he fell short in the finale. Aaron's chase of Ruth's sacred record prompted a flood of media attention, but also brought forth racist hate mail and death threats, which forced the Atlanta Braves to hire police escorts and bodyguards. When Aaron publicly revealed the hate mail he was receiving, he was deluged with supportive messages from fans. Babe Ruth's widow stated that her husband would have eagerly supported Aaron and his attempt at the record.

Aaron publicly stated his desire to hit number 714 and 715 in Atlanta. "I live in Atlanta, and that's where I want to hit the home run that ties the record and breaks the record." Although he tied the record on the road in Cincinnati, he hit the record-breaker on April 8 against pitcher Al Downing of the Los Angeles Dodgers in Atlanta–Fulton County Stadium.

Aaron rounds first base during his triumphant moment. The two young men seen emerging from the stands produced some tense feelings for some in the audience, especially in light of the threats Aaron had received. The two were only well-intentioned fans, however, eager to congratulate Aaron on his record.

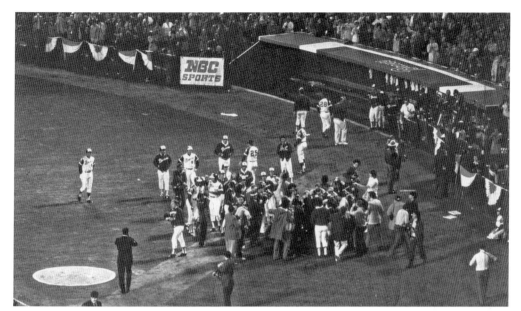

After he crosses home plate, Aaron is mobbed by teammates and members of the media. Aaron received the ball he hit over the fence from Atlanta Braves relief pitcher Tom House, who presented it to him just after this picture was taken. Reflecting on his struggle to break the record, Aaron said simply, "Thank God it's over."

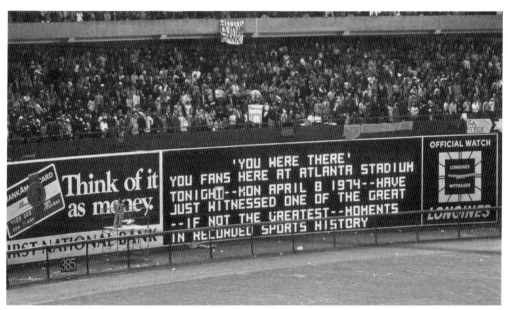

A record-setting crowd of 53,775 turned out to watch baseball history. To some, Braves fans had seemed apathetic during the last phase of Aaron's home-run chase. Attendance was appallingly low at the final home games of the 1973 season, despite intense interest around the country. An impressive attendance figure for the Braves' home opener was assured after an off-season of intense hype, when Aaron made clear his desire to break the record in Atlanta.

BASEBALL IN ATLANTA

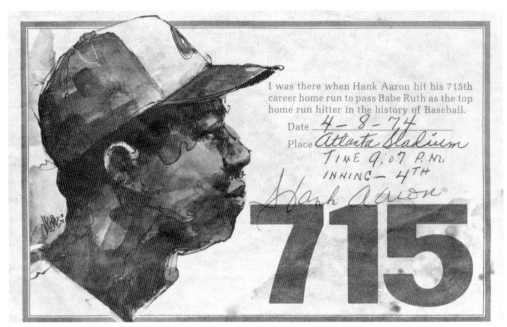

I was there when Hank Aaron hit his 715th career home run to pass Babe Ruth as the top home run hitter in the history of Baseball.

Date 4-8-74

Place *Atlanta Stadium*

TIME 9:07 P.M.

INNING — 4TH

Hank Aaron

715

A decal certificate was passed out to those in attendance during Aaron's record-breaking moment. Hank Aaron finished his career with 755 home runs before retiring in 1976. He was elected to baseball's hall of fame in 1982 and now works in the front office for the Atlanta Braves.

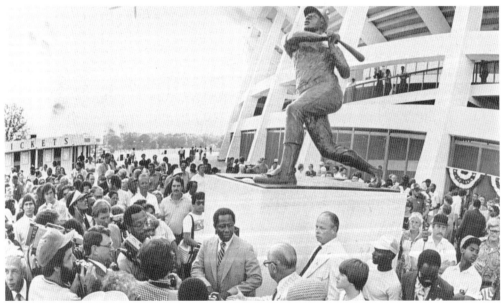

A nine-foot-tall statue of Aaron was unveiled at Atlanta–Fulton County Stadium in 1982. The 2,800-pound bronze statue is set upon a six-foot-high pedestal of white Georgia marble. When Atlanta–Fulton County Stadium was demolished in 1997, the statue was relocated to Monument Grove at Turner Field and now stands alongside monuments honoring Ty Cobb and Phil Niekro.

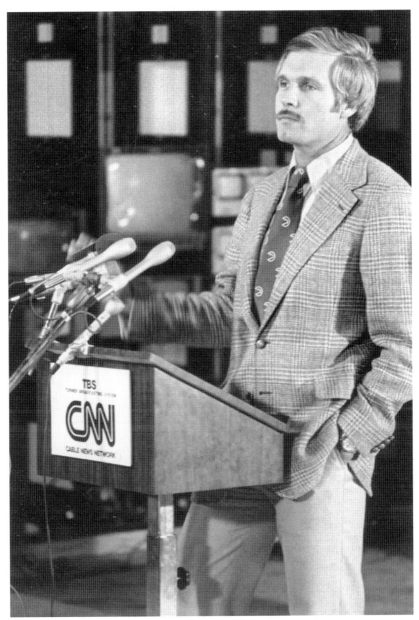

Although the Braves provided many exciting moments, the team failed to emerge as a contender. Attendance at home games dipped as rumors swirled of moving the franchise to another city, perhaps Denver or Toronto. Into this gloomy midst stepped Ted Turner, an enthusiastic and somewhat eccentric entrepreneur hell-bent on lifting the Braves out of their doldrums. Turner was already televising Braves games locally on WTCG when he bought the team for $11 million on January 6, 1976. A few years later, Braves games were broadcast coast-to-coast on WTBS. The new "Superstation" helped create Braves fans across the country as Turner began referring to them as "America's Team." In 1980, Turner expanded his cable empire by launching CNN, a 24-hour, all-news network that revolutionized the news industry.

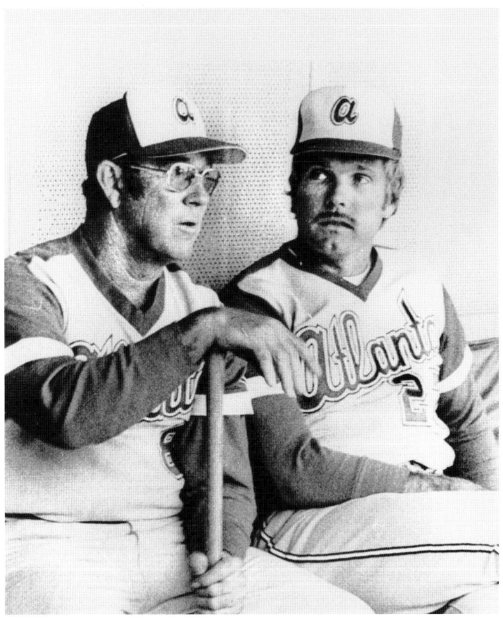

If Ted Turner could not produce an immediate winner, he was at least going to try to make it more interesting to come to the ballpark. In the tradition of Earl Mann, Joe Engle, and Bill Veeck, Turner instigated a series of bizarre promotions that added a circus-like aura to the Braves franchise. Throughout the 1970s, the Braves' promotion office staged frog-jumping contests, cash scrambles, tightrope walking, ostrich races, and Wedlock and Headlock Night (which combined a mass wedding and professional wrestling matches). Attendance rose. One of Turner's more interesting gimmicks occurred in 1977. In the midst of a horrible losing streak, Turner gave manager Dave Bristol a couple of days off and took the helm himself, guiding the team to a 2-1 loss to the Pittsburgh Pirates. (Atlanta Braves Museum and Hall of Fame.)

THE ATLANTA BRAVES

Braves pitcher Phil Niekro relied on his dancing knuckleball to retire hitters throughout his career. Bobby Murcer of the Chicago Cubs remarked, "Trying to hit him is like trying to eat Jell-O with chopsticks." "Knucksie" was an outstanding pitcher whose winning percentage far exceeded that of his team. Out of his 318 career victories, 121 occurred after his 40th birthday, a major-league record. Niekro is also in the record books with his brother Joe as the most prolific sibling pitcher duo. Their combined 539 career victories are the most of any brother combination in league history. Phil Niekro remained a loyal team member throughout some very lean years with the Braves. Coupled with his charitable causes, his longevity made him a very popular figure in team history.

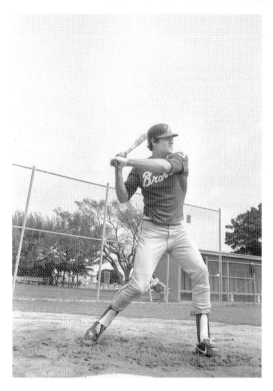

Dale Murphy takes a swing during spring training in 1983. Drafted as a catcher, Murphy reached the major leagues in 1977, but his success began in 1980 when he moved to the outfield and became an all-star. He was named the National League's Most Valuable Player in both 1982 and 1983, the youngest player ever to win the award in consecutive years. His success continued through the 1980s even as the Braves struggled as a team. He was traded to the Philadelphia Phillies in 1990 and finished his career with the Colorado Rockies in 1993. Murphy's career statistics included a .265 batting average, 2,111 base hits, and 398 home runs. He was a seven-time all-star and winner of five consecutive Gold Gloves. Always a favorite among fans and players alike, the Braves retired Murphy's No. 3 jersey in 1994.

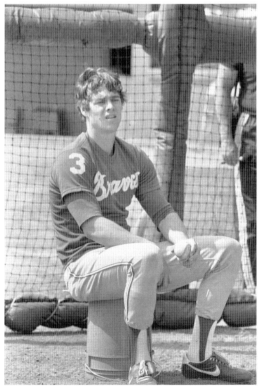

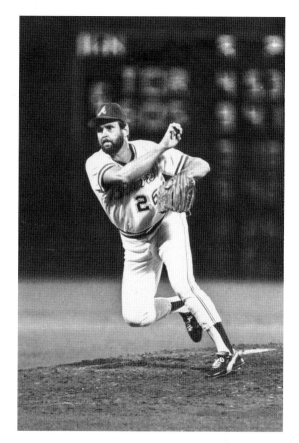

A nasty changeup and an unorthodox corkscrew delivery made relief pitcher Gene Garber a menace on the mound. Garber pitched for a succession of teams before being traded to the Braves in 1978. His prosperous career was highlighted by his famous duel that year with Pete Rose, who was in the midst of a 44-game hitting streak, the longest in National League history. After working the count to 2-2, Garber delivered his wicked signature changeup and ruined Rose's chance to break Joe DiMaggio's record of 56 consecutive games with a base hit. Garber proved instrumental in the Braves' 1982 season and stayed with the team through 1986.

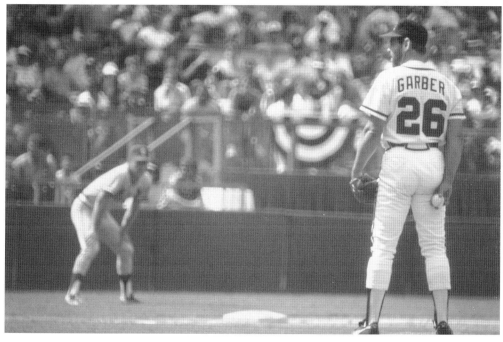

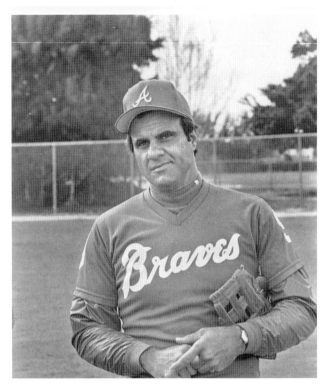

Joe Torre has enjoyed one of the most successful careers in the history of baseball. He made valuable contributions to the Braves and other franchises throughout the league. As a player, Torre was a nine-time all-star, Gold Glove Award winner, and the Most Valuable Player Award winner. As a manager, Torre guided a young but talented Atlanta Braves team to a playoff appearance in 1982 and later took the New York Yankees to four World Series championships.

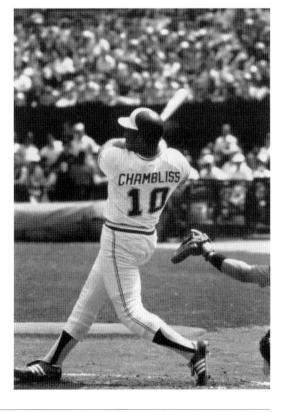

First baseman Chris Chambliss was a steady hitter for the Braves from 1980 to 1986. He played a key role in the Braves' 1982 Western Division championship, batting .270 with 20 home runs and 86 RBIs.

For many years, Atlanta–Fulton County Stadium had a reputation as the worst playing surface in the league. The stadium did not employ a full-time groundskeeper, and a city street crew maintained the surface. Players often complained about the field. The poor condition of the field was exacerbated by the fact that the Braves shared the same playing field as the Atlanta Falcons, whose football cleats damaged the sod. Circumstances improved beginning in 1989, when Braves management had the old infield ripped out and the stadium resurfaced. The Falcons began playing their home games at the Georgia Dome in 1992.

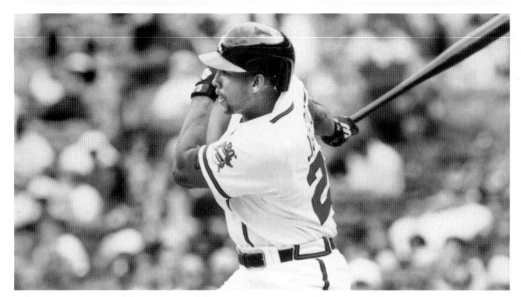

A hero in Game 6 of the 1995 World Series against the Cleveland Indians, David Justice, right fielder from 1989 to 1997, provided the crucial home run that helped the Braves clinch the championship with a 1-0 win. The 1990 Rookie of the Year and three-time all-star received a spot on the Atlanta team as a result of the trade of legendary favorite Dale Murphy. (Atlanta Braves Museum and Hall of Fame.)

Considered a stabilizing force in the infield, third baseman Terry Pendleton helped lead the Braves through the 1991 season into the playoffs. He was named National League MVP (1991), NL All-Star (1992), and Gold Glove winner (1992). After the strike-shortened season of 1994, he signed a contract with the Florida Marlins. Since the end of his playing career in 1998, he has coached in the Braves' system.

Fleet-footed outfielder for the Atlanta Braves from 1991 to 1993, and again in 1999, Otis Nixon was a threat every time he got on base. A career .270 hitter, Nixon amassed 620 stolen bases in 1,700 games. Nixon played for nine different major-league teams during his 17 seasons.

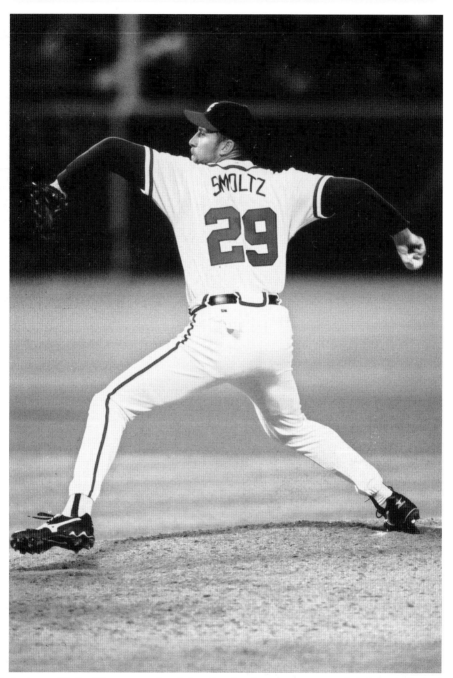

A likely future Hall-of-Famer, pitcher John Smoltz throws an unparalleled fastball clocked as high as 98 miles per hour. In the 1991 National League Championship Series, Smoltz pitched a complete-game shutout, leading the Braves to their first World Series in Atlanta. Having success as a starter and closer, the former Cy Young winner and seven-time all-star continues to be an impressive competitor as he approaches his 17th season with the Braves in 2007. (Atlanta Braves Museum and Hall of Fame.)

Larry Jones, better known as "Chipper" Jones, has proven to be a powerful and patient hitter since starting his major-league career with the Atlanta Braves in 1995. In 2006, Chipper became the Atlanta Braves' all-time hits leader, passing the great Hank Aaron with 1,902 hits. A mainstay in the Braves' lineup for over a decade, Jones is one of the finest switch-hitters in baseball history. (Atlanta Braves Museum and Hall of Fame.)

Seated side by side, the duo of pitching coach Leo Mazzone and field manager Bobby Cox oversaw 15 years of Atlanta Braves baseball together. Earning 14 division titles, the pair managed a team whose division winning streak is the longest in professional sports history. The image of Mazzone and Cox seated together on the Braves' dugout bench is a common memory for many Atlanta fans and a symbol of Braves' success throughout the 1990s. (Atlanta Braves Museum and Hall of Fame.)

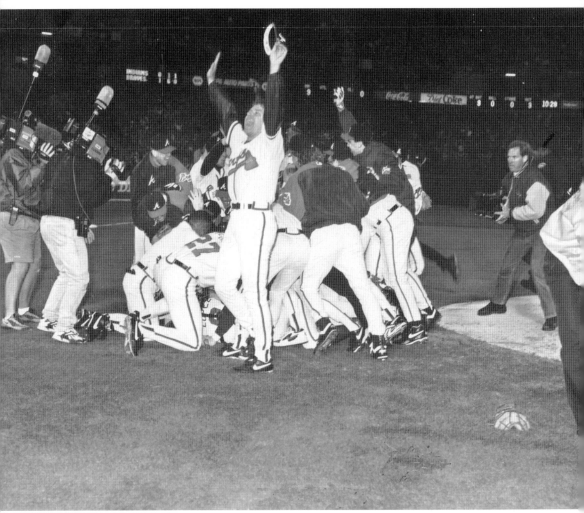

The 1995 World Series marked a number of milestones for the Atlanta Braves. After 38 years, the Braves finally won a world championship by defeating the Cleveland Indians four games to two. The pitching of Greg Maddux and World Series MVP Tom Glavine, coupled with the hitting of Ryan Klesko, Marquis Grissom, and Luis Polonia, brought the championship to the city. In game one, Maddux recorded only the 15th two-hitter in World Series history in beating Cleveland 3-2. Game six saw Tom Glavine record only the fifth one-hitter in World Series history and defeat the Indians 1-0. During the series, the Braves recorded a .244 average while their stellar pitching recorded a 2.67 ERA and kept the Cleveland average to a meager .179. (Atlanta Braves Museum and Hall of Fame.)

THE ATLANTA BRAVES

After years of frustration, the Atlanta Braves finally brought the World Series championship to Atlanta. Only the third championship in franchise history (1914 in Boston and 1957 in Milwaukee), the 1995 trophy was the first for the city of Atlanta. Often accused of supporting the team only when it wins, Braves fans were more than happy to express their joy in the 1995 celebration.

Ted Turner and wife Jane Fonda ride atop a fire engine during the celebratory parade.

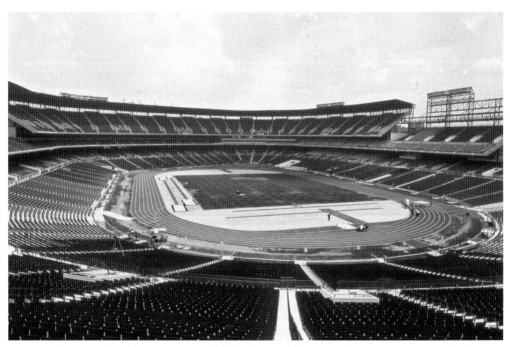

In 1990, the city of Atlanta was awarded the honor of hosting the 1996 Centennial Olympic Games. The games physically transformed the city, including the construction of the 85,000-seat Centennial Olympic Stadium. After the conclusion of the games, the stadium was renovated into a 45,000-seat baseball facility to host the home games of the Atlanta Braves.

During the singing of the national anthem, media-mogul billionaire Ted Turner stands beside wife Jane Fonda at Atlanta–Fulton County Stadium. Media attention focused on Turner's relationship with Fonda, an Academy Award–winning actress. The two were often spotted doing the "Tomahawk Chop" amongst fans at Braves' games. They separated in 2000 and divorced the following year. In 1996, Turner Broadcasting merged with Time Warner, a move that forced Turner to relinquish his controlling interest in the team. Time Warner later merged with America Online (AOL) to complete the largest corporate union in history and in 2005 announced its intention to sell the Braves franchise. (Atlanta Braves Museum and Hall of Fame.)

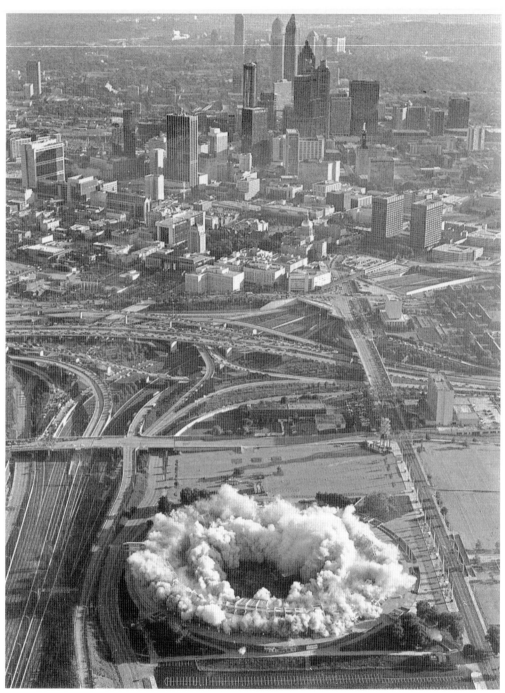

Atlanta–Fulton County Stadium, home to 30 years of sports memories, was detonated with over 1,000 explosive charges, each placed around the foundation pillars. The year before, a group called "Save Our Stadium" began a futile effort to preserve the structure to host international soccer games, but they were denied by the courts. The stadium that took one year to build was reduced to rubble and a cloud of dust in less than 30 seconds.

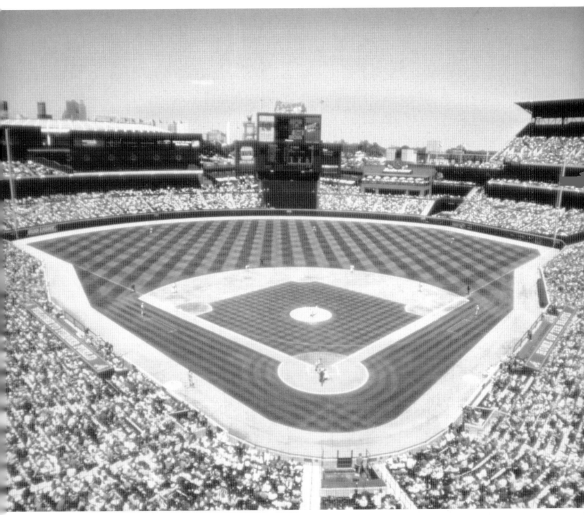

This view of Atlanta's Turner Field reveals the state-of-the-art, yet retro-inspired ballpark overlooking the Atlanta skyline. It first housed the Braves in 1997. Turner Field can now hold as many as 49,831 fans and is solely used for Braves baseball. Although the stadium is named after former owner Ted Turner, polls find that most Atlanta residents wanted the ballpark to be named after Hank Aaron, which instead became the name of the road on which the ballpark stands. (Atlanta Braves Museum and Hall of Fame.)

A five-time 20-game winner and two-time Cy Young Award winner, Tom Glavine is regarded as a key component to the decade-long winning streak of the Atlanta Braves. Picked in the second round by the Braves in the 1984 draft, Glavine's career includes the MVP award in the 1995 World Series. He neared the 300 victories milestone at the close of the 2006 season. Regarded as one of the better-hitting pitchers, Glavine's average is .188, with a season best .289 in 1996. Glavine played for the Braves from 1987 to 2003. That year, free agency took him to the New York Mets, where he signed a four-year, $42 million contract.

While serving as the on-field general of the Atlanta Braves, Bobby Cox has become one of the winningest managers in major-league history with over 2,100 wins and 1,600 losses. The decade of the 1990s was Cox's second stint as manager of the Braves. He first led the team in from 1978 to 1981. From 1982 to 1985, he served as manager to the Toronto Blue Jays. In 1985, he returned as the Braves' general manager. He fired himself in 1990 to take on the job of manager. In 1991, he led the Braves to their "Worst to First" season, the first of 14 division titles, and their first appearance in the World Series. Cox has been named Manager of the Year four times (1985, 1991, 2004, and 2005), the only person to receive the distinction of being Manager of the Year in both the American and National Leagues. Perhaps one of the less than stellar records held by Cox is that he is second on the list for ejections in a career, only nine behind the leader John McGraw, who was thrown out of 133 games.

General manager of the Atlanta Braves since 1991, John Schuerholz helped build the club into the perennial winner of the National League. With his hiring in February 1991, local newspaper headlines announced "Atlanta's in for some radical changes." In his years at the helm, the Braves have won their division 14 times and the World Series once (1995). In his recent book, *Built to Win*, Schuerholz makes the compelling argument that, like any other business, the building blocks to success include vision, communication, and respect. Before joining Atlanta, Schuerholz first worked for the Baltimore Orioles before spending 22 years with the Kansas City Royals, nine of them as general manager. During his tenure, the Royals won the World Series in 1985. Throughout his career, both in Kansas City and Atlanta, Schuerholz is regarded as very adept at developing and maintaining a fruitful farm system. In Atlanta, he was able to build from the base developed by his predecessor Bobby Cox to create the winning team of the decade.

BIBLIOGRAPHY

"Baseball Reference." Sports Records, Inc. www.baseball-reference.com/j/justida01.shtml.

Bisher, Furman. *Miracle in Atlanta: The Atlanta Braves Story*. New York: The World Publishing Company, 1966.

Couch, J. Hudson. *Braves First Fifteen Years in Atlanta*. Atlanta: The Other Alligator Creek Company, 1984.

Darnell, Tim. *The Crackers: Early Days of Atlanta Baseball*. Athens, GA: Hill Street Press, 2003.

Garrett, Franklin M. *Atlanta and Its Environs: A Chronicle of Its People and Events, Volume 1.* Athens, GA: University of Georgia Press, 1969.

Klapisch, Bob, and Pete Van Wieren. *The Braves: An Illustrated History of America's Team.* Atlanta: Turner Publishing, Inc., 1995.

Kuhn, Clifford M., Harlon E. Joye, and E. Bernard West. *Living Atlanta: An Oral History of the City, 1914–1948.* Athens, GA: University of Georgia Press, 1990.

"MLB Team Roster Pages Gateway." *Sports Illustrated.* sportsillustrated.cnn.com/baseball/mlb/players/.

Musick, Phil. *Hank Aaron: The Man Who Beat the Babe.* New York: Associated Features, 1974.

O'Neal, Bill. *The Southern League: Baseball In Dixie, 1885–1994.* Austin, Texas: Eakin Press, 1994.

Peterson, Robert. *Only the Ball Was White: A History of Legendary Black Players and All-Black Professional Teams.* New York: Oxford University Press, 1970.

"The Players." BaseballLibrary.Com. www.baseballlibrary.com/ballplayers/.

Ribowsky, Mark. *A Complete History of the Negro Leagues, 1884 to 1955.* Secacus, NJ: Carol Publishing Group, 1995.

"Ted Turner and Jane Fonda Announce They Are Separating." CNN. archives.cnn.com/2000/SHOWBIZ/TV/01/04/turner.fonda.02/index.html.

"Ted Turner: Media Visionary. Philanthropist. Statesman." Turner Enterprises, Inc. www.tedturner.com/tedturner/.

"Turner Field." Ballparks of Baseball. www.ballparksofbaseball.com/nl/Turner%20Field.htm.

Vaughan, Roger. *Ted Turner: The Man Behind the Mouth.* Boston: Sail Books, Inc., 1978.

Wright, Marshall D. *The Southern Association in Baseball, 1885–1961.* Jefferson, NC: McFarland, 2002.

ACROSS AMERICA, PEOPLE ARE DISCOVERING SOMETHING WONDERFUL. THEIR HERITAGE.

Arcadia Publishing is the leading local history publisher in the United States. With more than 3,000 titles in print and hundreds of new titles released every year, Arcadia has extensive specialized experience chronicling the history of communities and celebrating America's hidden stories, bringing to life the people, places, and events from the past. To discover the history of other communities across the nation, please visit:

www.arcadiapublishing.com

Customized search tools allow you to find regional history books about the town where you grew up, the cities where your friends and family live, the town where your parents met, or even that retirement spot you've been dreaming about.